WELSH MILITARY AIRFIELDS

THROUGH TIME

Alan Phillips

W0009885

AMBERLEY PUBLISHING

First published 2012

Amberley Publishing
The Hill, Stroud
Gloucestershire, GL5 4EP

www.amberley-books.com

Copyright © Alan Phillips, 2012

The right of Alan Phillips to be identified as the
Author of this work has been asserted in accordance
with the Copyrights, Designs and Patents Act 1988.

ISBN 978 1 4456 0993 5

British Library Cataloguing in Publication Data.
A catalogue record for this book is available from
the British Library.

Typeset in 9.5pt on 12pt Celeste.
Typesetting by Amberley Publishing.
Printed in the UK.

Introduction

It was inevitable that certain areas of Wales would be chosen as locations for airfields in times of conflict and war. The nation's distance from Continental Europe made it relatively safe from enemy attack and, therefore, ideally suited for training. It also due to its location on the western side of Great Britain near to the Western Approaches and the Atlantic convoys that the airfields in Pembrokeshire, as a peninsula, were ideally suited for Coastal Command operations into the Atlantic and the Bay of Biscay.

In Wales there were thirty-seven airfields and four relief landing grounds, eleven of which were operationally involved in air defence and maritime operations. Also there were numerous temporary landing areas attached to army camps associated with pre D-Day landings, which do not count as proper airfields.

During the First World War four bases were built in direct response to U-boat activities around the Welsh coast; two of the sites were utilised as airfields during the Second World War. In North Wales there were two bases both located near each other, one for training and the other an acceptance park.

The events leading to the outbreak of the Second World War resulted in the earmarking of several sites in Wales for airfield development, a programme which proceeded rapidly once war was declared. In Wales there were twenty-two airfields with concrete and tarmac runways. Ten had grass landing areas with the usual associated hangars and buildings. There were three seaplane bases, the aircraft factory at Beaumaris, the seaplane training base at Lawrenny and of course the flying boat station at Pembroke Dock. There were two main fighter stations (Valley and Fairwood Common) and a number of subsidiaries such as Angle, Llanbedr, Pembrey and Wrexham. Four airfields in Pembrokeshire became the responsibility of RAF Coastal Command, with Pembroke Dock being one of the main flying boat bases in Britain. The other airfields were built as Maintenance Units, training and support bases and even an aircraft factory.

Today, most of the airfields have closed with only one remaining in RAF use at Valley. Of the others, Rhoose has become Cardiff International Airport, while Aberporth, Swansea, Haverfordwest and Pembrey have become regional airports. Others have been returned to farming or reclaimed by nature. Hawarden (Broughton) is an Airbus factory producing wings for its airliners. One of the airfields has become an Army base, while another is a sand and gravel quarry. At the time of writing the future of St Athan and Llanbedr is not certain.

List of Airfields

Aberporth, Ceredigion
Angle, Pembrokeshire
Bangor, (Aber) Gwynedd
Beaumaris, Isle of Anglesey
Bodorgan, Isle of Anglesey
Brawdy, Pembrokeshire
Carew Cheriton/RNAS Pembroke (Milton), Pembrokeshire
Dale, Pembrokeshire
Fairwood Common (Swansea Airport), Glamorganshire
Fishguard Bay (Harbour), Pembrokeshire
Haverfordwest (Withybush Airfield), Pembrokeshire
Hawarden/Broughton, Flintshire
Hell's Mouth, (Porth Neigwl) Gwynedd
Lawrenny Ferry, Pembrokeshire
Llanbedr, Gwynedd
Llandow, Vale of Glamorgan
Llandwrog, Gwynedd
Manorbier, Pembrokeshire
Mona/Llangefni (RNAS Anglesey)
Pembrey, Carmarthenshire
Pembroke Dock, Pembrokeshire
Pengam Moor, Splott, Cardiff
Penrhos, Gwynedd
Rhoose, Cardiff Wales Airport, Vale of Glamorgan
St Athan, Vale of Glamorgan
St David's, Pembrokeshire
Sealand, Shotwick/Queensferry, Flintshire
Stormy Down, Vale of Glamorgan
Talbenny, Pembrokeshire
Templeton, Pembrokeshire
Towyn, (Tywyn) Gwynedd
Valley (Rhosneigr), Anglesey
Wrexham (Borras), Denbighshire/Clwyd
Satellite Landing Grounds and Relief Landing Grounds
 Chepstow SLG, Monmouthshire
 Rudbaxton SLG, Pembrokeshire
 Haroldston West RLG, Pembrokeshire
 St Brides, South Glamorgan

Aberporth, Ceredigion

The airfield is located near the village of Blaenannerch on the A487 Aberystwyth to Cardigan road. The entrance to the airfield is just off the B4333 road to the village of Aberporth.

The airfield covered an area of 118 acres consisting of three grass landing areas, the largest being 2,968 feet. The main camp site was located just off the Aberporth road and was officially opened in December 1940. By 1944 the airfield had two T2s and two blister hangars. Between 1941 and 1946 various Anti-Aircraft Co-Operation Units which were equipped with aircraft such as Henleys, Hurricanes, Tiger Moths, Spitfires and Queen Bees pilotless aircraft. When the main resident squadron No. 595 moved out in April 1946 the airfield was put on Care and Maintenance.

In 1951 the airfield was taken over by Royal Aircraft Establishment to support the nearby Aberporth missile range and in 1956 the runway 08/26 was tarmacked. It was later lengthened to 3,000 feet in the 1970s.

The airfield became part of DERA (Defence Evaluation & Research Agency) and more recently QinetiQ, operating in support of the Missile and Rocket Establishment that is situated south of the airfield.

In 2000 the airfield was acquired by the Welsh Development Agency and opened to civil use under the name of West Wales/Aberporth Airport.

Today, most of the wartime building have been demolished including one of the T2 hangars, and have been replaced by ultra-modern business/light industrial units specialising in high technology. The wartime parachute store, drying room and a few buildings remain as well as the unique wooden control tower, which dates post Second World War.

QinetiQ still uses the airfield but mostly for UAV trials.

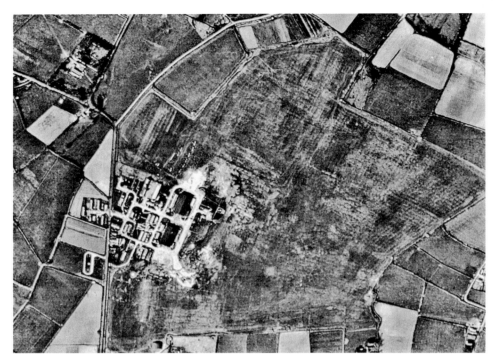

Aberporth aerial view, 1945.

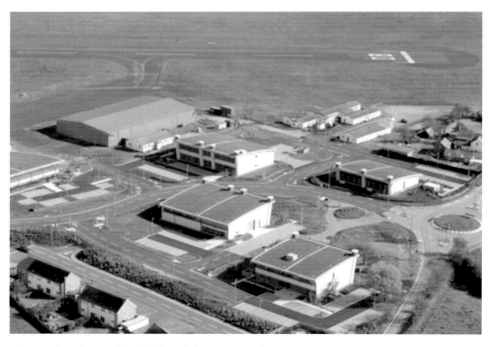

Aberporth today with its high-tech business park.

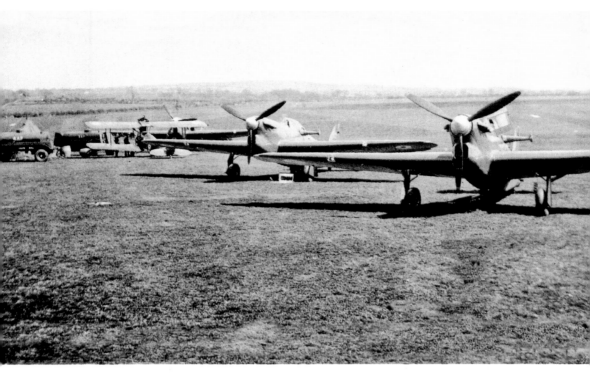

Hawker Henleys of No. 1 AACU were resident at Aberporth, 1940–42.

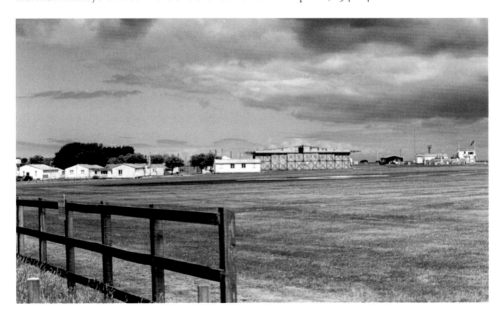

General view of the airfield in 2005. The tower, one of the Bellman hangars and a few other buildings remain.

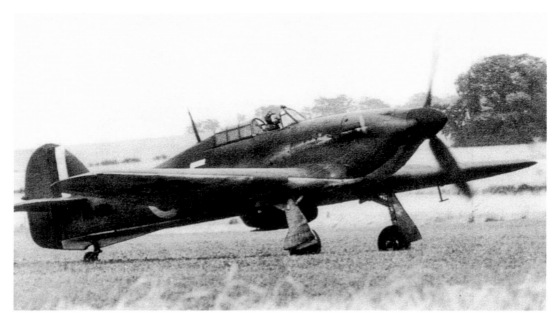

A Combined Services Projectile Development Establishment Hawker Hurricane taxiing.

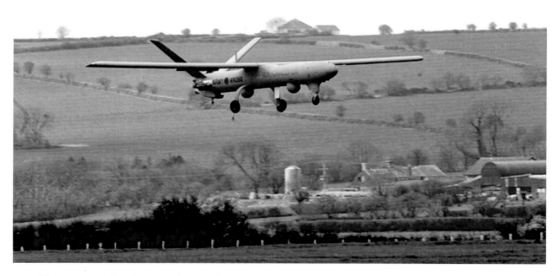

Watchkeeper UAV landing at Aberporth (via Thales).

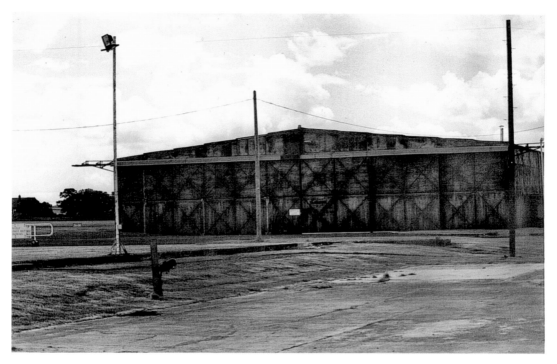

Aberporth's Bellman hangar in the 1960s, which has now been demolished.

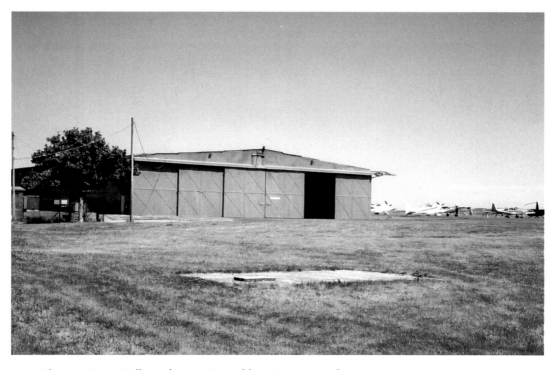

The remaining Bellman hangar is used by private aircraft.

Angle, Pembrokeshire

RAF Angle was planned and built during 1940 and became operational in May 1941. The airfield was located just off the B4320 road, which connects the village of Angle and Pembroke. However, on 1 December RAF Angle became a forward base in the Fairwood Common sector under No. 10 Group, Fighter Command with the responsibility of providing fighter cover for South Wales and the south-west of England. The airfield had three surfaced runways; the longest was 4,800 feet in length. The airfield had one T2 hangar and four over-blister type hangars and fourteen dispersal pens located on the south-eastern side, each large enough for four Spitfires. The first squadron to use the airfield was No. 32 Squadron with its Hawker Hurricanes in early June. Between 1941 and July 1943 several fighter squadrons operated from the airfield on convoy patrols and air defence including Westland Whirlwinds of No. 263 Squadron and Spitfires of No. 421 Squadron, Royal Canadian Air Force. In July 1943 the airfield was temporarily taken over by Fleet Air Arm, but in September was transferred back to the RAF and used for training.

RAF Angle was officially closed on 1 January 1946. One notable event took place on 29 May 1943 when a Short Sunderland piloted by F/O Gordon Singleton made the first ever dry landing at the airfield.

Today, the land has been returned to agriculture; all the runways, perimeter track and dispersal pens have been ploughed up. Until recently the firing butts were the only wartime structure left.

However, the layout of the airfield can still be seen from the air.

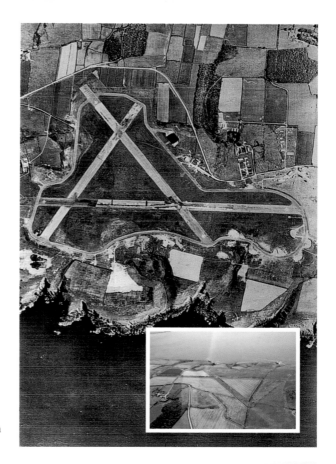

Aerial view of Angle airfield in 1945. *Inset:* The layout can still be seen today.

In the 1980s the firing butts were the only remaining wartime structure left on the airfield.

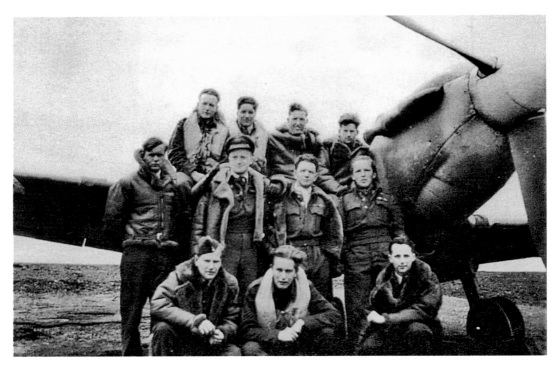

Pilots of No. 421 RCAF Squadron at Angle.

The runways and perimeter track was broken up and used as a foundation to the road
leading up to Angle power station.

Bangor, (Aber) Gwynedd

The landing site was situated on the coastal strip between Bangor and the village of Abergwyngregin in Gwynedd. Fifty acres of farming land belonging to Glan y Mor Isaf Farm was requisitioned in May 1918. Only minimum changes were done to the landscape to create a landing area of at least 1,000 feet. Several hedges were removed and ditches were filled in.

Four Bessoneau hangars were erected to store and maintain the aircraft. All accommodation, officers and other ranks were housed in tents and farm out-buildings. Other farm buildings were utilised as wireless rooms and for briefing air crews. Stores, fuel and ammunition were kept in nearby woods, away from the main site, protected by sand bags and covered by tarpaulin.

The first unit to be formed at RNAS Bangor was No. 530 Special Duties Flight as part of No. 244 Squadron in August 1918. The unit was equipped with Airco DH 6 for inshore patrols around the North Wales coastline. The squadron was disbanded on 22 February 1919 and in May 1919 the land was released for farming and returned to its owner Glan y Mor Isaf Farm.

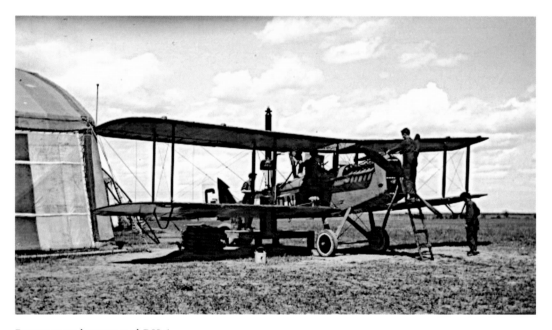

Bessonneau hangar and DH 6.

Beaumaris, Isle of Anglesey

This site was not classed as a military base but was used by the RAF as a weather diversion landing area for its Sunderland flying boats.

Most of the flying boat factories were located on the south coast of England and were constantly bombed by German aircraft. It was decided to move some factories further north, away from enemy attacks. One site for such a factory was a mile from the castle town of Beaumaris near Fryars House on the Menai Straits which had deep water and ample sheltered moorings. A small factory was built consisting of two Bellman hangars, workshops and hard standings for the flying boats with a connecting track way across a public road to a slipway. Further T2 hangars were also built and over the years all of the hangars were modified. The factory was built by the Ministry of Aircraft Production in September 1940 and was acquired by the Saunders Roe Company (Saro) in December. Saunders Roe was awarded a contract to modify the consolidated Catalina flying boats acquired through the Lend-Lease agreement. At Beaumaris the aircraft were anglicised with fitting of various British components to the aircraft, according to RAF Coastal Command specifications. The first Catalina arrived at Beaumaris on 28 April 1941 and for the next four years over 300 aircraft was converted at the factory. Several other American flying boats were modified by Saunders Roe including the Martin Mariner and the Consolidated Coronado; both were rejected by the RAF.

Several floatplane trials were conducted at the site with Fairey Swordfishes, Albacores, Hurricanes, Tiger Moths and Austers. Trials were also carried out by the Folland Aircraft Company in 1942 and again in in 1944 with a Spitfire VB and LFIXB fitted with floats. In 1945 most of Saro flying boat research moved back to their main factory at Cowes.

After the war the Beaumaris site was put forward as a flying boat base for the RAF, but was declined. In 1950 the Saro Company moved away from aircraft production at Beaumaris and concentrated on building fast patrol boats during 1953–55 for the world navies, such as the 'Dark class' boats. To keep the factory opened it was involved in building various equipment for the army and also bus bodies for the Leyland Company. In 1968 the site was taken over by Laird (Anglesey) Ltd producing the Centaur armoured vehicle; this was a Land Rover half-track. Eventually the facility closed in 1997 and the site was used as an industrial estate until 2006, although a number of the hangars were in need of refurbishment and repair. Today, the factory site is up for sale for development but most of the factory infrastructure is still there but in a dangerous condition.

A Martin Mariner flying boat in front of Fryars, Beaumaris.

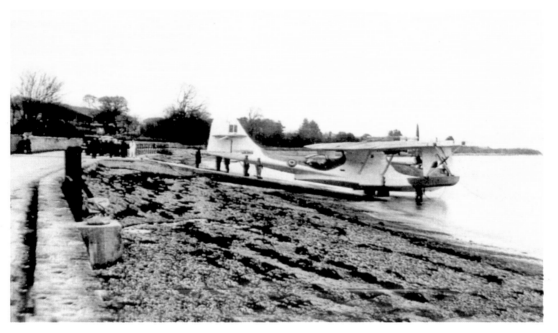

A Beaumaris Catalina on the slipway.

Bodorgan, Isle of Anglesey

This airfield is situated on the B4422 road some 8 miles west of Menai Bridge on the island of Anglesey. Some 200 acres of land belonging to the Bodorgan Hall estate was requisitioned in 1939 and the base was opened on 11 November 1940 as RAF Aberffraw but changed its name to Bodorgan in 1941. There were three grass landing areas of about 1,000 yards each. It had two Bellman hangars and one blister type and the usual Maycrete and Nissen buildings. The first unit to occupy the base was 'J' Flight of No. 1 Anti-Aircraft Co-operation Unit from RAF Penrhos. Between 1941 and 1945 varied Anti-Aircraft Co-operation units were based at Bodorgan equipped with Martinets, Tiger Moths, Hurricanes, Henleys and Queen Moths pilotless aircraft.

The airfield was also designated as SLG (Storage Landing Ground) No. 15 as part of No. 48 Maintenance Unit at Hawarden providing storage for an overspill of mostly Vickers Wellington bombers from the Broughton factory.

The airfield also provided target towing service for nearby airfields and other units in the area until it closed in December 1945. Today the land has been returned to its former owners for agriculture. Most of the facilities including the hangars were demolished in 1946, although part of the technical and administration sites remains.

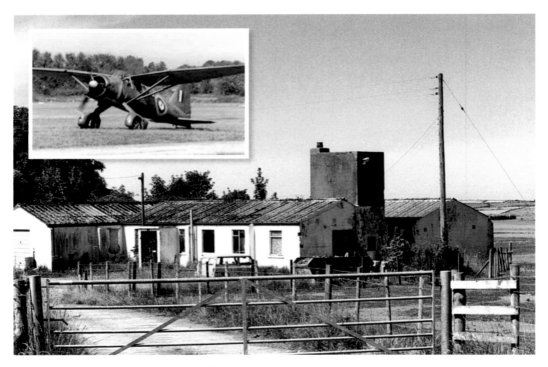

Main entrance and administration block at Bodorgan. *Inset:* In 1941 a detachment of Westland Lysander aircraft were based at Bodorgan.

An unusual pill box guarding Bodorgan.

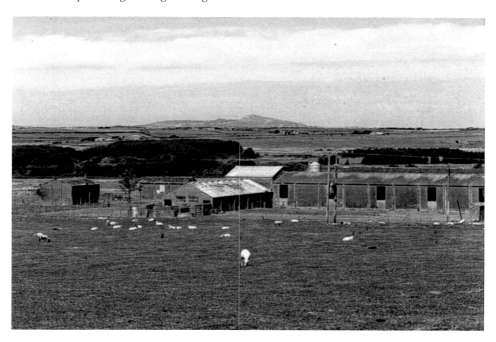

General view of Bodorgan technical site and landing area.

Brawdy, Pembrokeshire

Brawdy airfield is situated just off the A478 Haverforwest to St David's Road. The airfield became operational on 2 February 1944 as a satellite to nearby St David's, under the control of RAF Coastal Command. However, on 1 November 1945 station headquarters and its squadrons were officially transferred from St David's to Brawdy, leaving the former to become a satellite airfield. Brawdy had three concrete runways, two of which were 6,000 feet in length, capable of operating the heaviest Coastal Command aircraft at the time. There were twenty-seven spectacle-type dispersal points around the airfield. The main technical and administration site was on the west side between two of the runways while the main accommodation site was situated between the airfield and the main road. Only one T2 hangar was built during the Second World War for maintenance and storage. Another two were added when the headquarters moved from St David's in 1945.

The main squadron based at Brawdy was No. 517 Meteorological Squadron equipped with Handley Page Halifax, although other Halifax squadrons also used the airfield. In January 1946 the airfield was handed over to Admiralty control.

It was not until 1951 that extensive modernisation took place. All runways were lengthened by 500 feet and all taxiways and dispersal points resurfaced. Several new Main Hill and Mains hangars were built as well as a new Admiralty design control tower. The airfield was named HMS Goldcrest and was declared operational in 1956.

The Fleet Air Arm used Brawdy for training and provided a shore base for Royal Navy aircraft carriers while in port. The most common types seen at the airfield were Sea Hawks and the resident Fairey Gannet anti-submarine aircraft.

With the demise of the aircraft carrier, Brawdy was declared surplus to requirement and the RAF took control of the airfield again in 1971. Only minor alterations were done to the infrastructure, which included changes to the control tower. RAF Brawdy became the base for the Tactical Weapons Unit initially equipped with Hunters and then the Hawk trainer. TWU was disbanded in August 1992 and the RAF relinquished control of the airfield.

However, in 1996 part of the base was taken over by 14 Signals Regiment, Royal Corp of Signals, after extensive alterations costing well over £9 million became known as Cawdor Barracks.

Today, half the airfield infrastructures including the control tower and several hangars have been demolished. The runways are used for strait line motor racing.

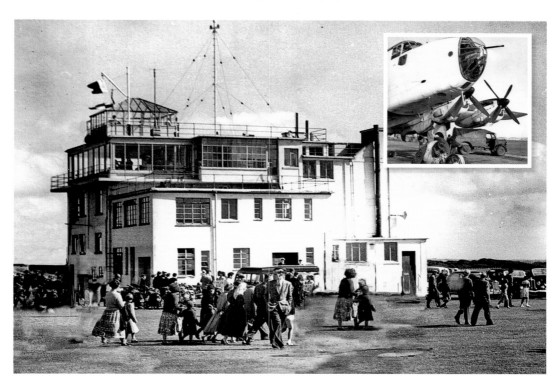

The Admiralty type control tower at Brawdy during the 1977 air display. *Inset:* Halifax GRII Srs of No. 58 Squadron undergoing final checks before a patrol.

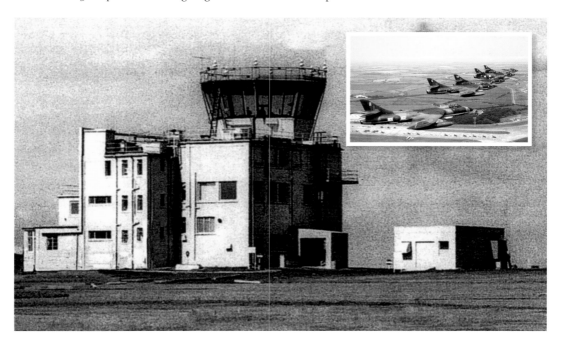

Brawdy RAF control tower. *Inset:* Hawker Hunters of No. 79 Squadron over Brawdy.

Naval Sea Hawks performing a
breathtaking display in 1957.

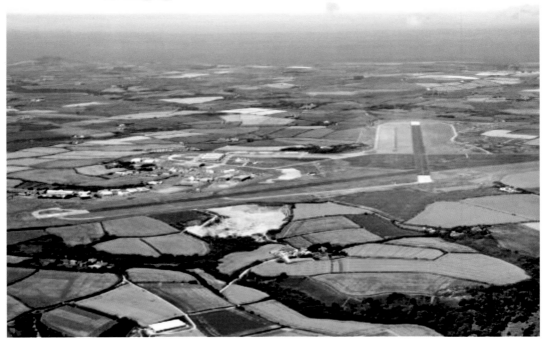

Brawdy airfield in the 1990s.

Carew Cheriton/RNAS Pembroke (Milton), Pembrokeshire

The site of the First World War airship station RNAS Pembroke occupied some 228 acres near the village of Sageston, just off the main road between Pembroke and Carmarthen. The airship station consisted of two 112 feet by 338 feet corrugated iron hangars with associate windshields and other infrastructures. Accommodation consisted of a mixture of wooden and canvas huts just off the main road. The station was officially opened in August 1915. The site operated Sea Scout SS type, the large Coastal class and the Sea Scout Zero SSZ type airships, which were actively involved in patrolling the sea lanes and the Western Approaches. In April 1917 three Bessoneau hangars were built in the south-east corner for the Special Patrol Flight equipped with Sopwith 1½ Strutter bombers and Airco DH 4.

The coastal patrol squadrons were disbanded during February and March 1919. In 1920 the Admiralty relinquished the site and it was eventually demolished. Some ten years later the site was chosen as a site for an airfield with concrete runways.

The site of Carew airfield was located more or less on the same site of the First World War airship station. Construction took place during the summer of 1938 and was opened a year later. Carew role was to support the flying boat station at Pembroke Dock, but during the Second World War it had two roles, operational and training under the control of No. 15 Group, Coastal Command. Carew airfield consisted of three concrete runways, two Bellman and two Bessoneau hangars with the main site located on either side of the A477 road. The first aircraft to be based at the airfield were Henleys and Tiger Moths of No. 1 Anti-Aircraft Co-operation Unit. At the outbreak of war several detachments were attached to the airfield for coastal patrols including Nos 48 and 217 squadrons with Avro Ansons. The airfield was bombed five times between July 1940 and April 1941 and, therefore, several fighter units were based at Carew for air defence and escort duties. The airfield was eventually transferred to Technical Training Command on 5 October 1942 and was officially closed on 24 November 1945.

The site is still evident from the air with many of the perimeter tracks and runways still visible but it is disappearing fast. There are remains of a few buildings scattered around the airfield. The re-routed A477 road goes through the middle of the technical and domestic site, although the unusual watch tower has been preserved and is now a museum.

RNAS Pembroke, 1918. (D. Brock)

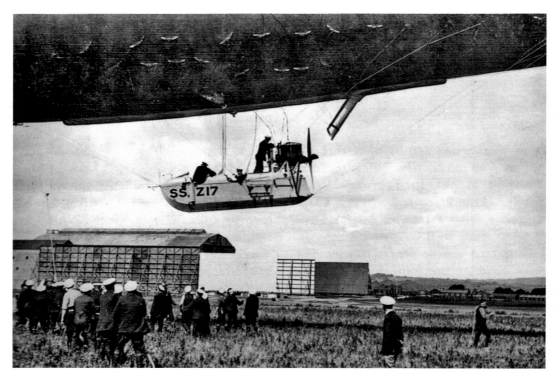

RNAS Pembroke SSZ17 taking off.

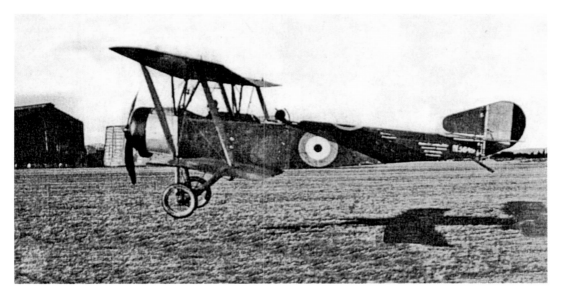

A Sopwith 1½ Strutter fighter bomber at RNAS Pembroke.

Avro Anson of No. 320 Dutch Squadron at Carew, 1940.

Carew watch tower in the 1950s.

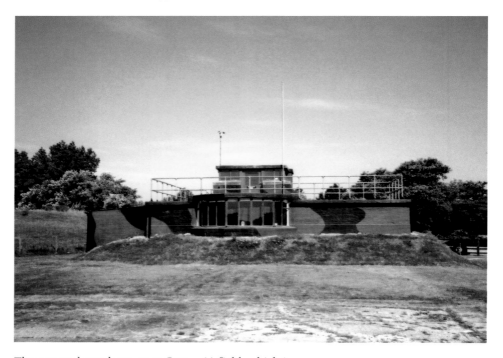

The restored watch tower at Carew Airfield, which is now a museum.

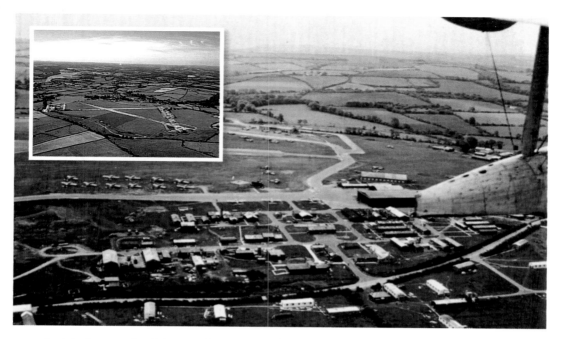

Aerial photograph of Carew taken in 1944 from a Sunderland. *Inset:* Carew Cheriton airfield today; the layout can be easily seen.

Dale, Pembrokeshire

The airfield was built in 1941 near the village of Dale as a satellite to Talbenny. It was situated just off the B4327 road some 12 miles from Haverfordwest on the northern side of Milford Haven, opposite the airfield at Angle. The airfield became fully operational on 1 June 1942 under the control of No. 19 Group, RAF Coastal Command. It had three concrete and tarmac runways, 3,495 feet, 4,215 feet and 4,785 feet in length. Dispersal points, hangars, workshops and most of the accommodation site were to the north-west of the runways with the main entrance towards Marloes. The first squadron to be based at the airfield was No. 304 (Polish) Squadron equipped with Vickers Wellington Ic. The aircraft flew maritime reconnaissance patrols in the Western Approaches and the Bay of Biscay until they left in March 1943.

In September 1943 the Admiralty exchanged its base at Angle for Dale which it regarded as better suited for Fleet Air Arm training operations. Under the Fleet Air Arm control an Admiralty control tower and several Mainhill, Main and Pentad hangars were built. It remained under Admiralty control until it closed on 13 December 1947.

Today, several of the airfield's structures such as the tower and most of the hangars have disappeared although some are still intact but deteriorating very fast and have been considered by CADW for preservation. From the air the airfield still looks serviceable.

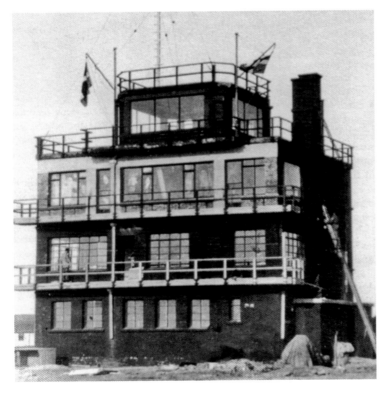

Dale naval type control tower, 1944.

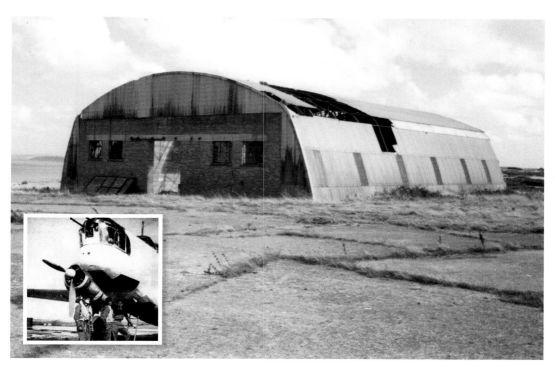

Mainhill hangar at Dale. *Inset:* Crew with Wellington of No. 304 (Polish) Squadron.

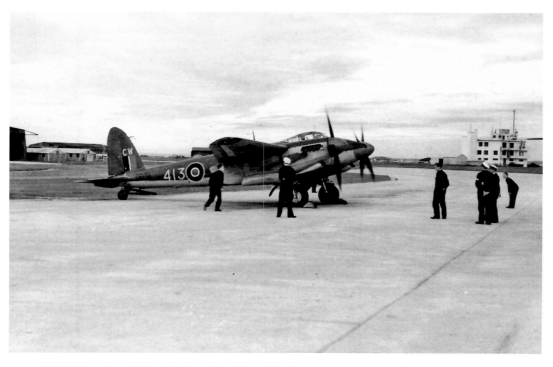

A DH Mosquito of No. 762 Squadron Fleet Air Arm.

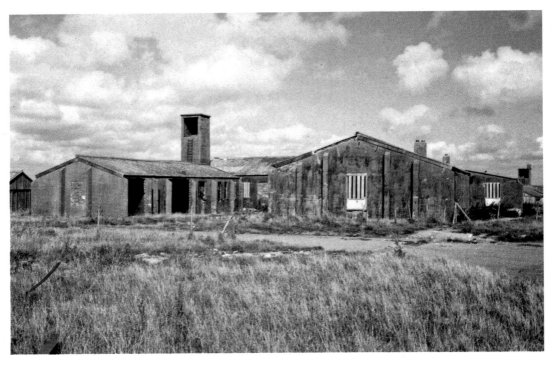

Several buildings remain and are being considered for preservation.

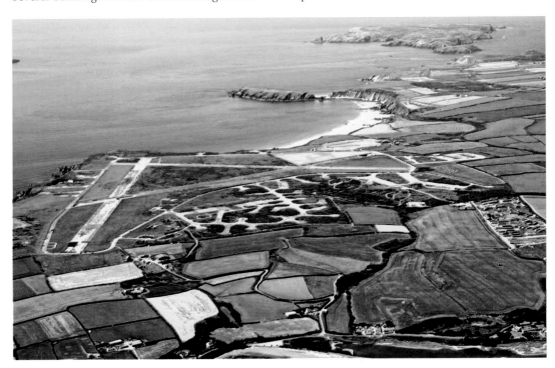

Dale Airfield as it is today. The general layout can be easily seen.

Fairwood Common (Swansea Airport), Glamorganshire

In July 1939 authority was given for the requisition of land known as Fairwood Common for the building of a fighter airfield for the protection of South Wales and the Bristol Channel. The airfield was situated on the Gower Peninsula, just off the A4118 Swansea to Port Eynon road and some five miles from Swansea.

The airfield had three main runways: the 4,800-feet north-east–south-west runway, and the west-east runway and north-west–south-east runway, both of which were 4,100 feet in length. All three runways were interconnected by a unique system of taxiways. Three Bellman and eight blister type hangars were built during the Second World War. In all there were forty-four aircraft dispersal and hard standing pens around the airfield perimeter. Most of the accommodation blocks were located in thirteen different sites to the west of the airfield and the A4118 road.

Fairwood Common was opened for No. 10 Group, RAF Fighter Command on 15 July 1941, becoming a full sector station on 25 October. The first fighter squadron to be based at Fairwood was No. 79 equipped with Hawker Hurricane Mk Is. Over the next few years the airfield became a home for numerous fighter squadrons involved in both day and night defence. One squadron that became renowned at the airfield was No. 125 Squadron equipped with Defiant and later Beaufighters. In 1943 the primary function of the airfield was training with air defence as a secondary duty. Two APC (Armament Practice Units) were established at Fairwood, which were primarily used by fighter bomber units of No. 83 and 84 Groups and units of the 2 Tactical Air Force. Between 1942 and 1945, fifty-eight fighters and fighter bombers were based or passed through the APC at Fairwood Common. The aircraft were Beaufighters, Defiants, Mosquitoes, Mustangs, Hurricanes, Spitfires, Typhoons and Whirlwinds. Several RAF squadrons also used the facilities post 1945 including Nos 595 and 691 training squadrons and the first jet equipped squadrons, Nos 74, 124 and 245, with Gloster Meteors. When the APC was disbanded in May 1946 the airfield was put on Care and Maintenance.

In 1956 the Air Ministry returned the airfield to Swansea Corporation and it was re-opened as Swansea airport on 1 June. The first scheduled flight from Swansea took place on 1 July 1957 to Jersey operated by Cambrian Airways. Over the next few years other airlines such as Morton Air Service, Trans European Airways, Derby Airways, Dan Air and Severn Airways operated scheduled services from Swansea Airport. In 1967 modest redevelopment took place with the strengthening and resurfacing of runway 02/44, which was extended to 6,000 feet and the installation of up-to-date landing aids.

The next phase of the development took place in the early 1970s when a new passenger terminal capable of handling up to 100 passengers was built adjacent to the tower. Dan Air continued to operate services to the Channel Islands until the company ceased trading in October 1992.

In 2002 Air Wales obtained an operating license for Swansea Airport on behalf of the local council and began operating a Swansea to Cork services until 2004. Air Wales ceased operations altogether in April 2006. In July Jaxx Landing Co. took over all airport operations and a master plan was drawn up to an extensive redevelopment including new hangars, new terminal and an extension to the main runway.

Very little of the wartime airfield remains today, the most prominent being the sole surviving Bellman hangar.

In the early 1970s the wartime tower was modified and a small passenger terminal was built. Inset: Only a small part of the airfield is used today as Swansea Airport.

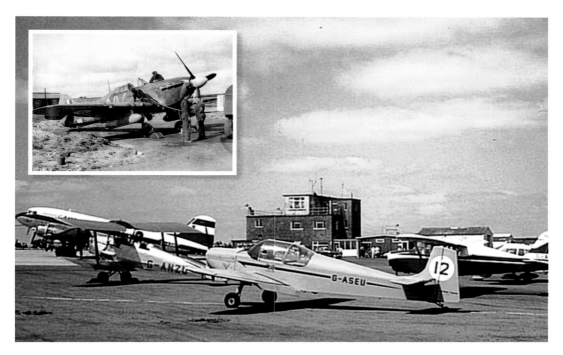

Various aircraft parked at Swansea Airport, 1969. *Inset:* Refuelling a Hurricane of No. 79 Squadron at Fairwood Common.

Several air taxi and private charters operate from Swansea Airport. *Inset:* Mechanics working on a Defiant of No. 125 Squadron, Fairwood.

Fishguard Bay (Harbour), Pembrokeshire

The RNAS seaplane station was located on the shore line sandwiched in between the northern breakwater and the port of Goodwick. It had a single slipway and launching crane on the break water. There were three adjoining buildings to house the seaplanes and one Bessoneau hangar. Further buildings were added later including accommodation, wireless room, guard room, women's rest room, photographic hut and workshops. The officers were billeted in nearby Fishguard Bay Hotel. The base was officially classed as operational in March 1917 and the first seaplane was delivered to the unit on 13 April 1917. There were two naval seaplane flights stationed at Fishguard equipped with Sopwith Baby/Fairey Hamble Baby and Short Type 184. The two flights became No. 245 Squadron on 20 August 1918, standardising on one type, the Short 184. The squadron was disbanded on 10 May 1919, by which time it had been reduced to just a few aircraft. Soon afterwards the station was closed and most of the infrastructure was dismantled and removed. However, the slipway and one of the hangars still remains.

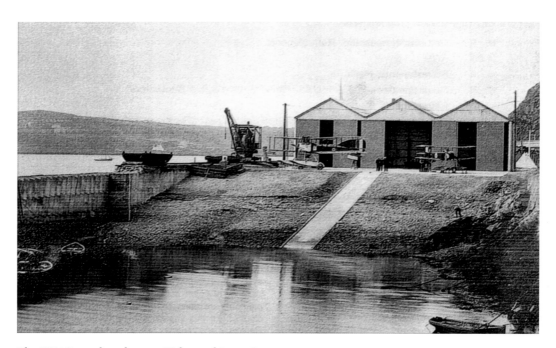

The RNAS seaplane base at Fishguard in 1918.

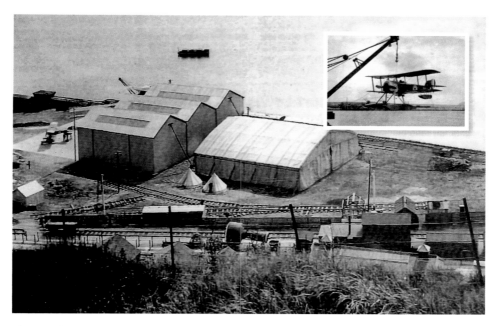

The seaplane base at RNAS Fishguard, 1917. *Inset:* Sopwith Baby seaplane being hoisted at Fishguard on 13 April 1917.

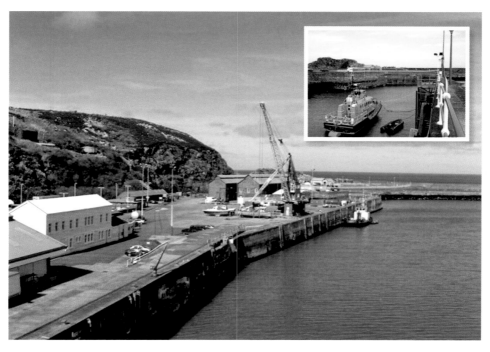

The northern breakwater at Fishguard Harbour with the remaining First World War shed. *Inset:* A jetty near the site of the seaplane station.

Haverfordwest (Withybush Airfield), Pembrokeshire

The aerodrome is situated at a place called Withybush, about two miles north of Haverfordwest, just off the A40 road to Fishguard. The site was chosen in 1940 and within months land and homes were requisitioned. The airfield was officially opened in November 1942 for No. 17 Group of Coastal Command, but was not fully operational until the following year. The airfield had three runways, 04/22 5,100 feet, 17/35 3,780 feet and 10/28 3,600 feet with connecting perimeter track and thirty-two dispersal hard stands areas, branching out into surrounding fields. There were two T2 hangars situated near the technical site and administration blocks, and seventeen dispersal pans. The accommodation blocks and other communal sites were situated just off the A40 road and scattered in nearby fields.

The first unit to be based at Withybush was No. 3 Operational Training Unit with Ansons, and Whitley and Wellington bombers. Due to limited parking space at the airfield, 'O' Flight was despatched to the satellite airfield at Templeton.

The unit was joined in January 1943 by more Wellingtons of No. 7 OTU, but was renamed in May as No. 4 Refresher Flying Unit. Another unit based at the airfield at the time was General Reconnaissance Aircraft Preparation Pool.

No. 4 RFU was disbanded in September 1944. In January 1945 the photo-reconnaissance unit No. 8 OTU equipped with thirty Spitfires and Mosquitoes moved in to the airfield and stayed until June. The last units to leave Haverfordwest were Nos 20 and 21 Air Crew Holding Units. The airfield was officially closed in January 1946.

Pembrokeshire County Council acquired the airfield from the Air Ministry in 1952 for civil use. In 1949 a study concluded that there was a need for a civil airport in West Wales; Haverfordwest Council put forward Withybush airfield and after lengthy consideration Withybush was chosen. Only minor alterations were required at the time as most of the wartime infrastructure was intact.

On 24 May 1952 Cambrian Airways began a twice daily scheduled service to Cardiff (Pengam Moor) using a Dragon Rapide G-AJCL. A stop-over in Swansea was later added and the service continued until 1955 when Cambrian withdrew from the route. By 1958 the runways had deteriorated to such an extent that several airlines refused to operate from the airfield. It was not until the 1970s when the county council realised the potential of the aerodrome and redeveloped the site. The engineering section was sold and today consists of a number of small businesses; the wartime control tower was refurbished and is an office. Most of the wartime buildings are occupied by local companies while the one remaining T2 hangar is used by an agriculture firm and on Sundays as a market.

After the 2004 review 'Aviation in the UK', which emphasised a need for a flexible air service in Wales, great effort was put in to upgrade facilities at Haverfordwest. Work had begun in 2000 and a new hangar, a small terminal waiting room and a café were built. A new state-of-the-art control tower became operational in 2004, replacing the control caravan previously used.

Today, another two hangars have been built together with parking aprons and an airside apron in front of the terminal. Only one of the wartime runways has been upgraded, (04/22), which has permanent inset lightning system and PAPIS. The main entrance is just off the A40 Fishguard road.

The remaining T2 hangar and crew rooms at Withybush in 1993.

One of the new hangars at Haverfordwest with a YAK 9 display team parked outside.

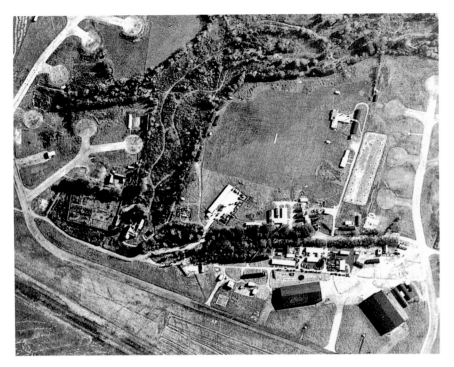

An aerial view of Withybush airfield's two T2 hangars and part of the camp taken in 1946.

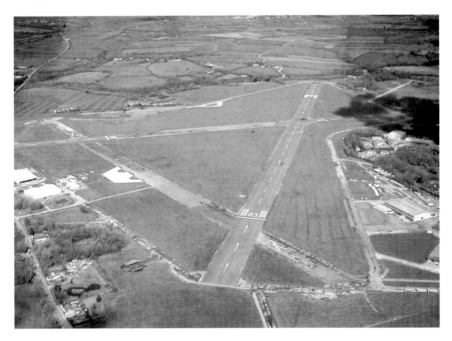

Today the general layout of the airfield has changed. This photograph was taken in 2001.

Refurbished Second World War control tower at Haverfordwest.

Haverfordwest Airport new control tower and offices built in 2004.

Hawarden/Broughton, Flintshire

Hawarden airfield can be split into three categories: aircraft production, aircraft storage and flying training. It is located at Hawarden and near the village of Broughton, some three miles from Chester.

The site was initially chosen in 1935 for a shadow aircraft factory but it was not until February 1939 that the factory was completed. At the time it was one of the largest factories in Europe with 141,000,000 square feet of working space and had sufficient space for expanding.

From the outset the factory was originally part of the Vickers Armstrong Group, but became a government-owned facility, under the guise of MAP but managed by Vickers to build the Wellington bomber. The first Wellington to leave the factory was L7770 in August 1939. During a production peak in 1942, 130 aircraft per month left the production line and by 1945 a total of 5,540 Wellingtons were built at Broughton. Vickers also built Lancaster bombers on behalf of the Avro Aircraft Company.

In the post war period the factory built 28,000 pre-fabricated houses for the Ministry of Supply.

In 1948 the factory was taken over the by the De Havilland Aircraft Company, who had a substantial order book for the Mosquito, the Hornet and their jet fighter, the Vampire. In the early 1960s the company built the Canadian Beavers for the British Army and the Sea Vixen for the Fleet Air Arm. In 1963 De Havilland was absorbed into the Hawker Siddeley Group and built the Hawker Siddeley 125 executive jet and parts of the fuselage for the Nimrod aircraft. In 1971 the factory began producing wings for the Airbus A300B. On 29 April 1977 the company merged with the British Aircraft Corporation to become British Aerospace.

Initially the airfield consisted of a grass field with one short concrete runway for testing the aircraft. There was also the large assembly hall, a flight shed, Bellman hangars and a number of wooden huts used for administration, canteens and drawing offices.

Hawarden airfield is built on requisitioned land adjoining the aircraft factory, part of which had been used by RAF Sealand as a relief landing ground. Most of the construction took place during 1940. The first unit to arrive at the airfield was No. 48 MU on 6 March 1940, whose primary responsibility was preparing the Wellingtons for operational use. The MU became one of the main aircraft storage units in the UK and remained at Hawarden until July 1957. Other units based at Hawarden were No. 7 OTU responsible for training fighter and fighter reconnaissance pilots.

By August 1940 the OTU had fifty-eight Spitfires, seventeen Miles Masters and six Battle target towers. In December 1940 the unit was redesigned No. 57 OTU and remained at Hawarden until November 1942. During the D-Day offensive in July 1944 over a thousand US troops were transported in 59 Douglas C47 Dakotas from Hawarden. Other units based at Hawarden during war years were Nos 41 and 58 OTU, Ferry Pool Flights, Nos 808 and 885 Feet Air Arm Squadrons. The RAF element at the airfield closed on 31 March 1959 and complete control of the airfield was handed over to De Havilland. By the end of September 1945 there were a total of 1,177 aircraft parked at the airfield, most of which were due to be broken up for scrap.

The airfield was quite an impressive sight as it had three runways – the 3,291-foot 14/32, the 4,713-foot 05/23, and the 3,291-foot 01/19 – with at least over a hundred concrete-based frying pan dispersals. RAF Hawarden had six T2, six 'L' type, three 'K2' type and one 'J' type hangars.

The main site including administration, sick quarters and some accommodation blocks are situated to the north of the airfield. Site 4, the OTU camp, was situated at the south-west end of the station, opposite to the aircraft factory.

Today, part the OTU site is an industrial estate while the rest has been taken over by a large Airbus assembly hall for producing wings for their airliners. The old MU site is also used by light industry with hangars and buildings adjacent to the railway line occupied by the Raytheon Company.

Hawarden is run by Airbus UK as Chester Hawarden Airport and is still used by aircraft belonging to Airbus.

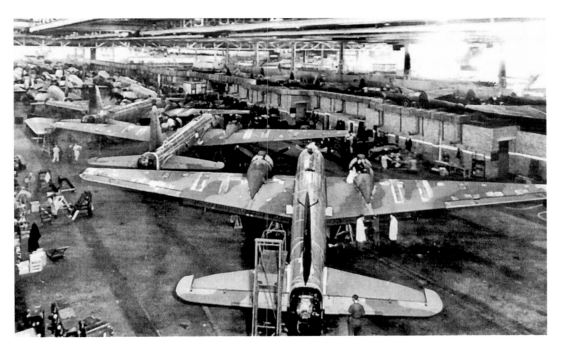

Vickers Wellington bomber production line at Broughton.

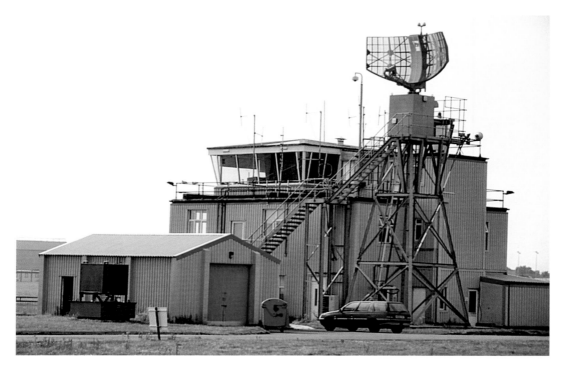

Hawarden refurbished control tower.

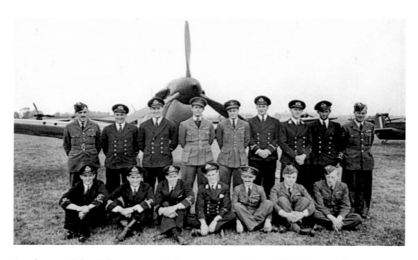

Students of the July 1940 training course at No. 7 OTU Hawarden.

Hell's Mouth,
(Porth Neigwl) Gwynedd

Hells's Mouth airfield was situated on the tip of Lleyn Peninsula in North Wales. The nearest village was Llanengan with Abersoch two miles way.

The site was first used in 1937 as an air to ground gunnery range for No. 5 Armament Training Camp at Penrhos. In early 1940 four Bellman hangars with an adjoining concrete apron were built. The rest of the camp was located at the northern end of the grass landing area. Due to poor weather the gunnery range eventually closed and the airfield was reopened as a Relief Landing Ground for RAF Penrhos. Due to shortage of space at the former airfield No. 9 (O) AFU became residents at Hell's Mouth in 1942 until it was disbanded in June 1945 and soon after the base closed. The majority of the buildings and hangars were demolished in 1946. Today, only the concrete base of building remains together with a few air-raid shelters and blockhouses.

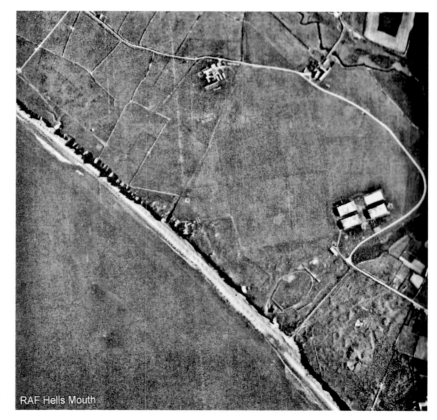

A aerial view of RAF Hell's Mouth taken in 1945.

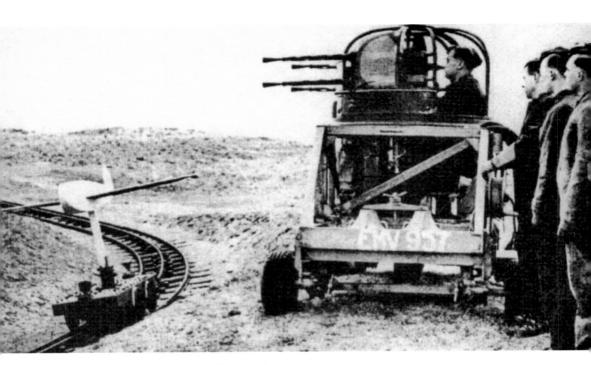

A power-operated gun turret at Hell's Mouth.

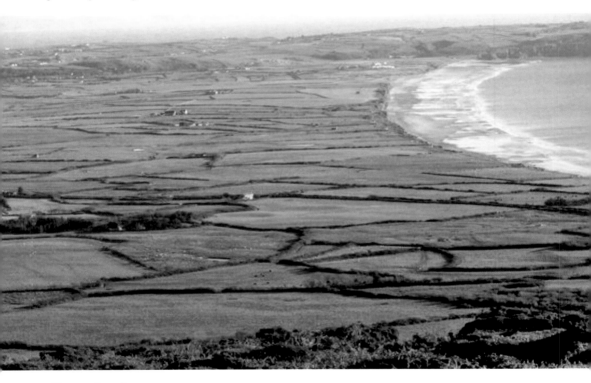

Hell's Mouth today.

Lawrenny Ferry, Pembrokeshire

This small seaplane base was situated four miles from Pembroke on the north shore of the junction of the Cresswell and Carew rivers with the Eastern and Western Cleddau. The site was chosen by the Royal Navy for training its seaplane crews. The base provided a sheltered area for training and consisted of a single Mains hangar (60 feet by 70 feet), an 18-foot slipway, three concrete aircraft pens and storage for some 4,800 gallons of fuel. There were no workshops and accommodation for officers and petty officers was provided at Lawrenny Castle. Other ranks were accommodated in two Nissen huts nearby.

The base was commissioned on 1 February 1942 although No. 764 Squadron moved from Pembroke Dock in October 1941. The squadron was equipped with Supermarine Walruses and Seafoxes. Towards the end of 1942 the squadron was supplemented with Chance Vought Sikorsky Kingfisher floatplanes. Advance training continued until the squadron was disbanded in November 1943. The base reverted to care and maintenance in November 1943 with the provision that it could be re-commissioned within three months.

By 1944 the need for such a base had diminished and it was finally closed. Today, very little remains of the base. The slipway is still intact and is used by the Lawrenny Yacht Club. The hangar and Nissen huts were demolished in 1945 and their location is a site for caravans and holiday chalets.

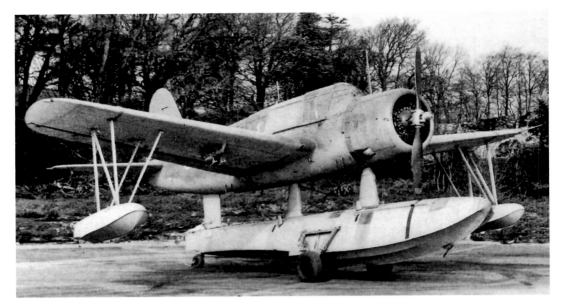

Vought Sikorsky Kingfisher of No. 764 Squadron.

Lawrenny Ferry slipway today.

Llanbedr, Gwynedd

In August 1940 a narrow coastal plain between the sand dunes of Morfa Dyffryn and the village of Llanbedr was requisitioned for development of an airfield as a forward fighter base to provide air cover for coastal convoys. Construction of the airfield took place through the winter months and was officially opened as a RAF camp on 15 June 1941 under the control of RAF Valley. The airfield consisted of two concrete and tarmac runways – the 4,328-foot 05/23 and the 4,207-foot 16/34 – with one T2 and four blister type hangars. The main camp was situated east of the airfield between runways 16 and 23 just off the public road leading to the sand dunes with a secondary site some two miles near the A466 road. The first aircraft to use the new airfield were Tiger Moths of the Elementary Flying Training School followed in September by a detachment of six Ansons of No. 6 Air Observer and Navigation School, which remain until January 1942. The first front-line fighter squadron to use Llanbedr was No. 74 Squadron equipped with Supermarine Spitfires on 4 October 1941. From October 1943 to February 1945 Llanbedr was the home of two armament practice camps, Nos 12 and 13 APC equipped with their own target towing flight. Between 1941 and 1945 thirty operational fighter and fighter bomber squadrons with various types of aircraft passed through Llanbedr. The squadron's secondary duties were coastal patrols over Cardigan Bay and the Irish Sea. By the summer of 1942 enemy activity had diminished and the airfield reverted to its role as gunnery training base. The last unit to be based at Llanbedr was No. 631 Squadron equipped with Henleys, Hurricanes, Martinets, Vengeances and Spitfires which left in February 1949.

In 1951 the base came under the control of the Royal Aircraft Establishment. On 16 October 1951 No. 5 Civilian Anti-Aircraft Co-operation Unit (CAACU) was formed at the airfield providing target towing for nearby army ranges with Mosquito TT20s and Gloster Meteor TT8s.

After No. 5 CAACU left in 1958 target towing continued, operated by Short Brothers who provided pilotless drones for target practice. Aircraft used were Firefly and Meteors. In 1960 Jindivik specially built target drones arrived at Llanbedr and remained the main drones until the introduction of the supersonic Stiletto drone. Eventually the unit operated Canberras, Meteor U16s, BAE Hawks and Alpha jets. RAE Llanbedr worked in close support with RAE Aberporth providing targets for guided missile tests and also with the Guided Weapons Development Squadron at Valley. In 1955 there was considerable redevelopment at the airfield. A new north–south, 7,500-foot runway was built to cope with modern jet aircraft and newer pilotless drone entering service. Another two T2 hangars and one Bellman hangar were built. Several of the wartime buildings were refurbished and new control tower was built overlooking the main runway.

In 2004, the Ministry of Defence announced that because of the advancement and complexity of modern missiles, Cardigan Bay was not regarded as a safe sector for missile testing and, therefore, there was no need for Llanbedr. The final sortie took place on 28 October 2004 and the base was closed early 2005. QinetiQ, the new owners, planned to sell the airfield for private flying and light industry. In December 2008 the Welsh Assembly gave the go-ahead for Kemble Airport to acquire the site to use as an airport, but due to local objections from different sources its future was in doubt. However, in 2011 a certificate was granted to Llanbedr Airport Estate to use the site as an airport.

Today, there are only two T2 hangars remaining which are in good condition. Most of the wartime camp had been replaced by newly-built buildings. The wartime control tower remains but has been replaced by a new one built in the early 1960s. The communal site near the main road is more or less the same as it was. It became the Maes Artro Museum but has since closed.

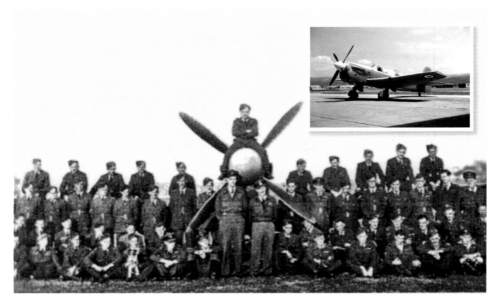

Line up of personnel of No . 41 Squadron at Llanbedr. *Inset:* Firefly U.8 WJ152 at Llanbedr in 1959.

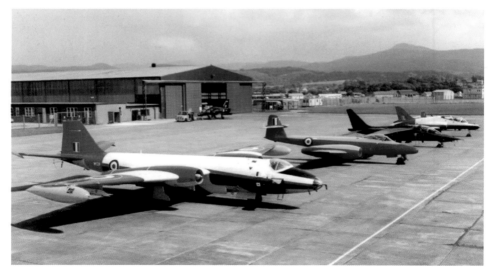

Line up of aircraft used by Qinetic at Llanbedr in 2002.

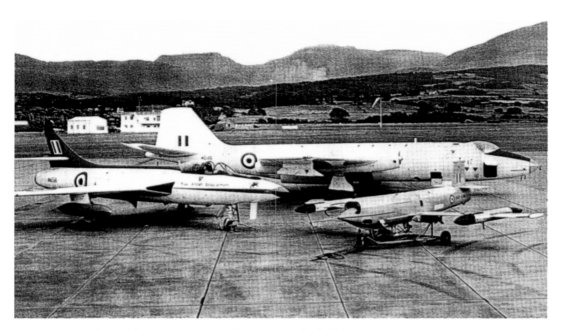

Line up of aircraft used by RAE in the 1970s at Llanbedr.

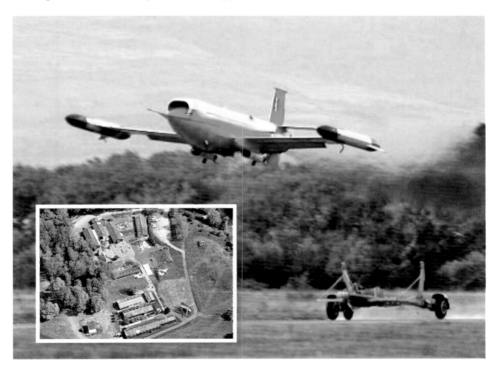

Llanbedr Jindivik pilotless drone taking off. *Inset:* Part of the Communal site at Llanbedr became Maes Artro Museum.

Llandow, Vale of Glamorgan

In March 1939 approval was given for the acquisition of farm land just south of the village of Llandow, some two miles from St Athan.

From the outset the airfield had a dual function for maintenance and flying training. Work on the site proceeded with urgency and by the outbreak of the Second World War, land had been cleared with a few basic wooden buildings and a grass strip. Permanent structures were added and by the autumn three surfaced runways had been built – the main runway was 4,800 feet and the other two were 3,300 feet. A concrete perimeter track was built complete with forty frying pans and five loops dispersal areas, some branching out into nearby fields. Like most MU sites it had a diverse collection of hangars around the airfield.

The airfield was divided into two sites: the main site on the northern side and the west site complete with hangars and associated buildings. The main accommodation and other communal area were located in fields to the south-west. After completion the airfield had thirteen Super Robin, twelve Blister type, seven 'L' type, two 'K' type, two T2, one A1 and one 'J' type hangars.

The first unit to use the airfield was aircraft belonging to No. 614 Squadron from Pengam Moor during training exercises. No. 38 Maintenance Unit was formed at Llandow on 1 April 1940 as an Aircraft Storage Unit. The first aircraft to arrive were Westland Lysanders followed by Fairey Battles, Tiger Moths and Fox Moths. Later they were joined by Blenheims, Spitfires and Whitleys. In 1943 Albemarles, Bostons, Mustangs and Lancaster bombers were stored at the airfield. By November 1945 there were 856 various types of aircraft parked at the airfield. A metal track roadway was built connecting Llandow and St Athan with aircraft dispersal areas on ether sides. An area near Sigingstone was used in 1945 for scrapping the aircraft.

In August 1940 the airfield was attacked by a lone Ju 88 causing slight damage to one of the 'L' type hangar. The MU remained at Llandow until it was disbanded on 15 March 1957.

Another unit formed at Llandow was No. 3 Overseas Aircraft Preparation Unit in July 1943 and was disbanded a year later. The main training unit based at the airfield was No. 53 OTU, which arrived in June 1941. By the end of the year the unit had thirty-six Spitfires, fourteen Miles Masters and four Master Target Towing. As earlier versions of Spitfire became available the unit's strength increased to seventy-five aircraft by the following January. The unit was involved in training pilots in single seat fighters and air-air combat. No. 53 OTU left in May 1943.

During the post war period Llandow became the base for the newly reformed No. 614 (County of Glamorgan) Auxiliary Squadron in August 1947 equipped with Spitfire L16es, which were replaced by jet fighter DH Vampires in July 1950. The squadron was disbanded in March 1957.

Another unit at Llandow was No. 4 Civilian Anti-Aircraft Co-operation Unit equipped with target towing versions of the Beaufighter and Mosquitoes, which was formed at the airfield in August 1951 and left in July 1954.

Before all civil flying was transferred to Rhoose, several flights operated from Llandow. Unfortunately on 12 March 1950 a Fairflight Avro Tudor (G-AKBY) crashed at Sigingstone on approach to the airfield. Eighty passengers lost their lives in the tragedy.

Llandow remained for some years as a storage satellite for St Athan, but due to its short runways it became unsuitable for heavy jet operations.

Today, the runways and sections of the perimeter track at Llandow are part of the public roads that crosses the airfield. The B4270 road follows large parts of the perimeter track. The southern end of the airfield has a go-kart racing track. Most of the wartime hangars are still intact and are used by businesses and storage companies. The main site is referred to as Llandow Industrial Estate. The control tower has been refurbished and transformed into offices and a café. From the air the airfield is virtually unchanged since 1945.

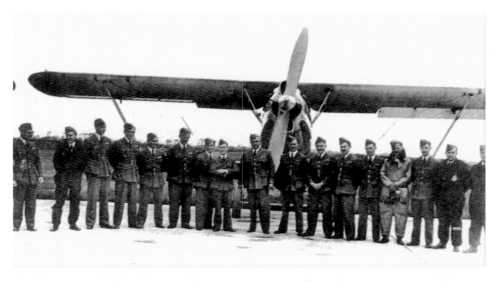

The first unit to be based at LLandow was No. 614 Royal Auxiliary Air Force Squadron.

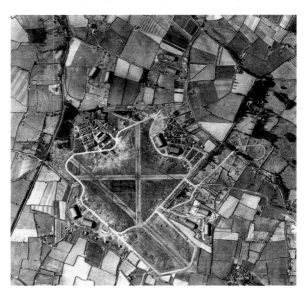

Vertical photograph of RAF Llandow taken in 1944 with aircraft stored in every available space.

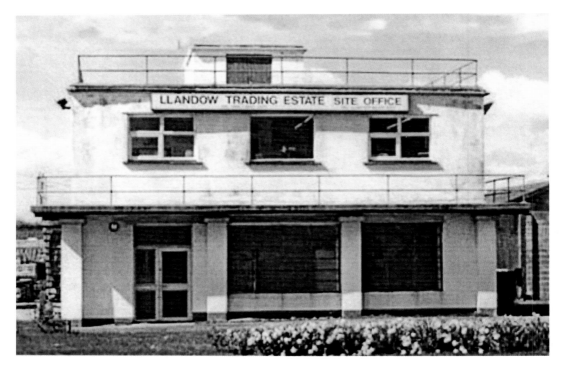

Llandow tower has been used for various purposes during the years.

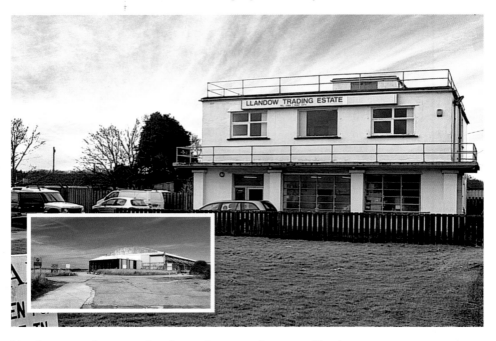

Llandow control tower today. *Inset:* An empty hangar at Llandow.

Llandwrog, Gwynedd

The site of Llandwrog airfield is on a peninsula situated between Caernarfon Bay and Foryd Bay at the western entrance to the Menai Straits. The area which consisted of mostly low sand dunes, pebbly beaches and fields was a former tank training ground. The airfield is four miles from Caernarfon and the nearest village is Dinas Dinlle.

The airfield was built in 1940 and was officially opened as a training base on 11 July 1941, although No. 9AGS (Air Gunnery School) was formed at the airfield five days previously. Llandwrog had three concrete and tarmac runways in a triangular layout – runway 03/21 was 3,100 feet by 150 feet, runway 14/32 was 2,990 feet by 150 feet and runway 09/27 was 3,000 feet by 150 feet. By 1945 there were eight hangars, two T2s, one Bellman and five over blisters. The technical site, administration section, sick bay and the control tower (watch office) were situated on the south side of the runways. Communal areas were situated a mile away on the Blythe and Chatham farmland, over the inlet of Foryd Bay. Access to the site was over a wooden bridge.

The first aircraft to use Llandwrog were twelve Whitley bombers and twelve Lysander target towing aircraft. In June 1942 the unit was disbanded and replaced by No. 9 (Observers) Advance Flying Unit which remained at the airfield until its disbandment in June 1945. Parent unit of the OAFU was based at Penrhos and its fleet comprised of Ansons, Blenheims, Defiants, Lysanders and Whitleys. Several other units used the airfield including No. 11 FTS.

RAF Llandwrog is renowned for the formation of the RAF Mountain Rescue Service thanks to people like Flt Lt George 'Doc' Graham and his medical staff at the station sick quarters.

In 1946 RAF LLandwrog, which was on Care and Maintenance, was used by No. 277 Maintenance Unit (Explosive Disposal Unit) for storing the large amount of chemical weapons stockpiled by the Nazi regime in Germany. Twenty-one Bellman hangars were built on the airfield's three runways for storing 14,000 tons of Tabun nerve gas weapons, which were disposed of in the Atlantic in 1954 and the MU was closed in 1956 after the site was made safe and all hangars demolished. The airfield was refurbished in 1969 for the investiture of the Prince of Wales at Caernarfon Castle and was acquired by Keenair for private flying in 1975 and became Caernarfon Airport. In 2002 the airport was taken over by Mr Roy Steptoe who has since invested a great deal of finance and effort into the airport.

Today, the airport has a flourish flying club providing training for both fixed wing aircraft and helicopters as well as pleasure flights around North Wales. It is also the base for the Air Ambulance helicopter. Most of the wartime infrastructure has been demolished except for a few buildings scattered around the airfield and the technical site. The wartime control tower, used until recently as a tower and offices with adjoining café, is in the process of being demolished. A new hangar complex was built complete with a control tower, offices, school rooms and a café.

On site there is the Caernarvon Aero Park Museum containing a wonderful collection of aircraft that were stationed in Llandwrog and in Wales, together with various exhibits for the aviation enthusiasts.

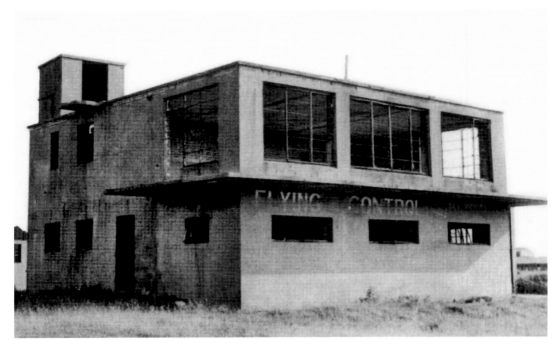

Llandwrog control tower in the 1960s before renovation.

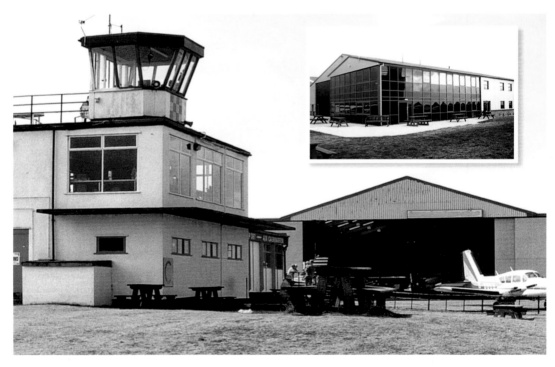

Renovated Llandwrog (Caernarfon Airport) tower and one of the hangars. *Inset:* The new terminal, hangars and control tower at Caernarfon Airport.

Manorbier, Pembrokeshire

There were two camps at Manorbier, the Army School of Anti-Aircraft Artillery and the RAF landing strip which provided the school for target towing and pilotless aircraft.

The camp is situated a mile east of Manorbier just off the B4585 road and some five miles from Tenby. The Army camp dates back to 1932 although target towing aircraft of No. 1 Anti-Aircraft Co-operation Unit used the field in 1937 during a summer camp training session. The following year the AACU returned with Queen Bee pilotless aircraft. By 1939 both the army and RAF camp had permanent buildings. The AACU moved to its new base in May 1939 in support of No. 3 Heavy Anti-Aircraft Practice Camp which had been established at the school. The RAF camp and technical site including a Bellman hangar was situated to the east of the grass strip, with additional accommodation in a field leading up to the B4585 road. The landing area consisted of three landing strips of about 1,500 feet to 2,400 feet. Towards the end of 1941 there were thirty-five Queen Bees on the unit's strength. From the outset the area was susceptible to flooding during the autumn and winter months. A novel solution to the problem was the construction of naval hydraulic catapults similar to those installed in Royal Navy cruisers. These catapults were installed on the cliff tops launching the Queen Bees over the sea.

The Army school located to the south of the landing strip and near the cliff top consisted of a number of wooden school rooms, accommodation blocks, administration buildings, sick quarters and mess halls. Situated around the cliff tops were various concrete bases for the guns which were used by the school.

During the cold war the school was upgraded to be capable of utilising the guided weapons entering service. Also in the 1960s a new housing estate was built to house the permanent staff at the camp.

The pilotless unit was disbanded in March 1946 and the RAF camp closed. Since then, the land has reverted back to agriculture but has been retained for possible future use as the Army still occupies the Manorbier Artillery School. Today, the RAF camp has been completely demolished and the school is a fraction of its original size. A new helicopter pad has been built and a number of buildings converted for servicing UAVS. The refurbished Bellman hangar is still being used by the school. The guard room which dates back to 1937 situated by the main entrance is still used.

Due to poor drainage, Queen Bee drones were launched by catapult off the cliff top.

Mona/Llangefni (RNAS Anglesey)

RNAS Anglesey was located on a 200 acre site between the A5 and the B5109 roads and some three miles from Llangefni. The air station consisted of one large 120 foot by 318 foot airship shed with large windshields on either end. Several wooden and corrugated huts were constructed as workshops, stores and for gas production units. The accommodation site and a Bessoneau hangar which was added later were situated near the main road. RNAS Anglesey was a base for Sea Scout SS type, Sea Scout Pusher SSP type and Sea Scout Zero Type SSZ airships. On 6 June 1918 No. 521 (A Flight) and 522 (B Flight) Coastal Patrol Flights was formed at Llangefni equipped with eight Airco DH 4s. The Flights were part of No. 255 Squadron RNAS until 15 August, when the unit moved to the new base at Aber (Bangor) where it was renumbered No. 244 Squadron. The Llangefni site was ideal for airships but the ground was rather uneven for aircraft operations. The station closed in 1919 but the Admiralty did not relinquish the site until 1920.

Mona airfield was constructed on the former airship base in 1941 and was officially opened in December 1942. It had three runways, the longest being 5,383 feet (05/23). Most of the technical site, administration and accommodation were situated on the south-eastern side of the camp. The airfield had three T1 hangars, two next to the main site and the other on the west side of the airfield. Also seventeen over blister hangars were constructed around the airfield. The first unit to move in was No. 3 Air Gunners School equipped with forty-eight Blackburn Botha and fourteen target towing aircraft. They were replaced by the formation of another training unit, No. 8 Observers Advance Flying Unit with Avro Ansons. When the OAFU was disbanded in June 1945, the airfield closed the following May. From 1951 the airfield was used as a relief landing ground for RAF Valley. To accommodate modern jet aircraft runway 05/23 was lengthened to 6,000 feet and a crash barrier was installed. Since 1974 the airfield has been the home for the Mona Flying Club.

In 2001 part of the site was used in the foot and mouth epidemic as a location for burying carcasses. Today, two of the T1 hangars, the blister hangars, and most of the wartime buildings have been demolished. The original control tower was demolished in 2005 and an new one was built by the Ministry of Defence.

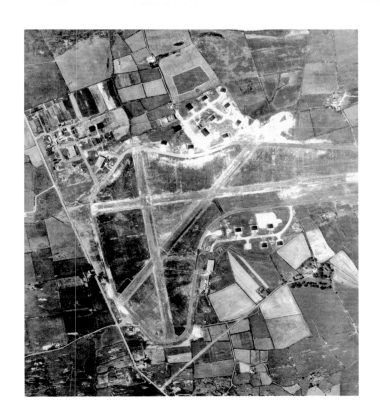

Vertical photo of Mona airfield taken in 1945.

New Mona control tower built in 2005. *Inset:* RNAS personnel outside the officers' mess at Anglesey in 1918.

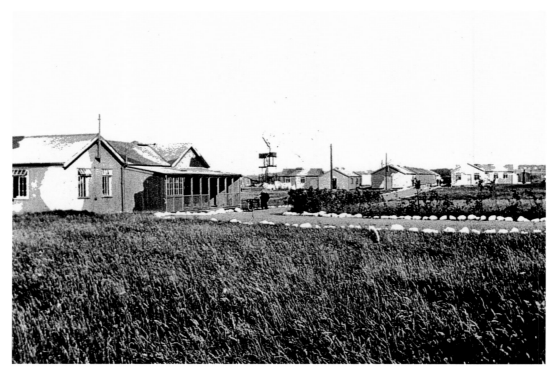

RNAS Anglesey officers' quarters in 1918.

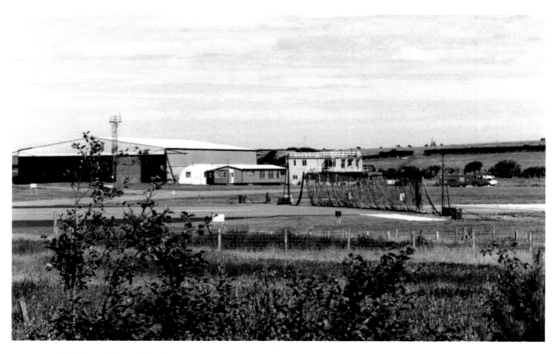

Mona airfield is still used by the RAF. Note the crash barrier erected during touch and go flights.

Pembrey, Carmarthenshire

The site for Pembrey airfield was acquired in 1937 and during its construction it was allocated to No. 25 Group of Training Command, but was not officially opened until 6 May 1940. The airfield is located on a site known as Towyn Burrows, some two miles from Burry Port. Originally it was to have a grass landing area but due to frequent flooding three concrete and tarmac runways were built (5,200 feet, 4,020 feet and 3,540 feet) with twenty-seven dispersal pans. By the end of the war the airfield had four 'F' type, two Cranwell, three VR 1 and thirteen blister type hangars constructed. The main site including the technical section was to the north-east of the airfield while the gunnery school and accommodation known as Towyn Camp was situated towards the south-east end of the airfield.

Initially, the first unit to be formed at Pembrey was No. 1 AGS for the training of air gunners. On 20 June 1940 the airfield was transferred to No. 10 Group Fighter Command to provide air defence in the South Wales sector and convoy protection. The first fighter unit to be based at Pembrey was No. 92 Squadron with Spitfires on 18 June 1940. In response to considerable enemy night activity in the area detachments from Nos 256 and 307 squadrons equipped with Defiants and later Beaufighter night fighter units were stationed at the airfield in January 1941. For the next two years several Spitfire and Hurricane squadrons were based at the airfield.

With the building of new airfields at Fairwood and Angle the importance of Pembrey as a fighter station diminished and in June 1941 the airfield was transferred to Flying Training Command but reverted back to Fighter Command in June 1945.

No. 1 AGS became the main unit at the airfield, initially with thirty-nine Blenheims and thirty-one Lysanders. By late 1943 this changed to thirty-six Ansons and twenty-seven Martinets. Before the unit was disbanded in June 1945, it had twenty-seven Wellingtons, eight Martinets, ten Masters and nineteen Spitfires.

In October 1945, No. 595 Squadron arrived at the base to provide support in the training ranges nearby. The squadron was renumbered in February 1949 and was re-equipped with Vampire jet trainers, but left for Chivenor in October. The next unit to be formed at Pembrey was No. 233 Operational Conversion Unit in September 1952 as a fighter pilot training unit equipped with Vampires and Hunters. The unit was disbanded in September 1957 and the station was closed soon afterwards. Pembrey remained under Ministry control, but most of the site returned to public use in 1958. A substantial part of the airfield is privately owned by Mr Winston Thomas, who has developed the site for private flying complete with a new tower, passenger terminal with check-in facilities, departure lounge, restaurant, offices and two new hangars. It was officially opened by the Secretary of State for Wales in August 1997. Only a section of the main runway (04/22) is in use and was lengthened in 2011 from 2,641 feet to 3,937 feet.

Today, there are still a few remaining wartime buildings left on the site including the two of the F type hangars which has been completely refurbished and are used for industry and agriculture. On the southern side of the airfield is the Pembrey Motor Racing Circuit.

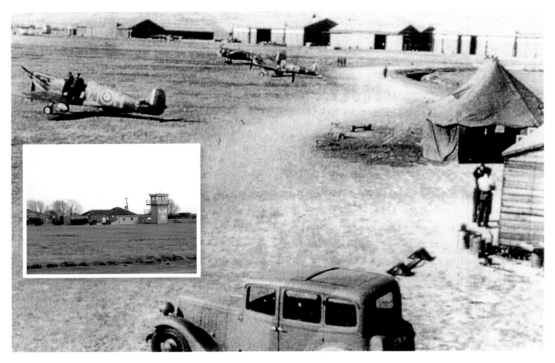

Spitfire Mk1s of No. 92 Squadron at Pembrey during the summer of 1940. *Inset:* Pembrey Airfield as it is today.

DH Vampire of No. 5 Squadron at Pembrey in 1949.

Pembroke Dock, Pembrokeshire

The flying boat station at Pembroke Dock was officially opened on 1 January 1930. Initially, the base consisted of a few wooden huts, a wooden jetty and a slipway. There was one blister type hangar which was demolished when the 'B' type hangar was built. The main alighting area was in Pembroke Reach and had maximum run of about 4,900 feet. Moorings for the flying boats were adjacent to the base and at Neyland Trot, Burton Trot and Hobbs Point Trot.

During the early 1930s the base was gradually expanded with a new concrete slipway, an elegant Georgian style officer's mess, brick-built sergeant's and airmen quarters and new workshops. To accommodate the newer flying boats entering service, two 'B' type hangars were built, the eastern hangar in 1934 and the western hangar in 1938. A T2 hangar was also built for storage and maintenance in 1943.

Two slipways were built in 1936, one being 1,121 feet with a mechanical winch while the other was 200 feet with a floating dock nearby. The station was surrounded by a stone wall on the landside.

The first squadron to be based at Pembroke Dock was No. 210 with Short Southampton flying boats in May 1931. The squadron remained at the base equipped with various flying boats until July 1940. Most of the squadrons were eventually equipped with Short Sunderland flying boats, and in all there were at least ten Sunderland operational squadrons and one training unit based at Pembroke Dock in a period between 1939 and 1945. The Sunderland covered a patrol area of the Bay of Biscay, the Western Approaches and well into the Atlantic Ocean.

Another unit based at Pembroke Dock was No. 78 Maintenance Unit which was involved in all major Sunderland servicing and repairs.

In the post war period the main Sunderland units were Nos 201 and 203 squadrons. No. 4 OTU (renamed to Operational Conversion Unit) and the Flying Boat Training Squadron were equipped with three Sunderland flying boats. The last Sunderland was officially withdrawn from RAF service in February 1957 and No. 208 Squadron was disbanded at Pembroke Dock. The station was put on Care and Maintenance on 31 March 1957 and was officially closed and returned to Admiralty control in 1959, which eventually sold the site for development.

Today, most of the site is occupied as a ferry terminal, although the two 'B' type hangars have been renovated and are used by engineering firms. The Georgian officer's mess and the airmen barrack block were demolished in the 1980s while the sergeant's mess located just inside the elegant main gate was converted into a hotel. The other accommodation site has been developed into housing estate.

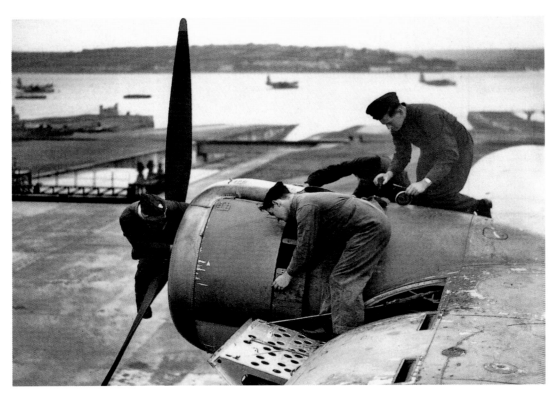

Maintenance on the Sunderland's Bristol Pegasus engine.

One of the 'A' type hangars in its original state before refurbishment.

The flying boat station's guardroom and fort style wall.

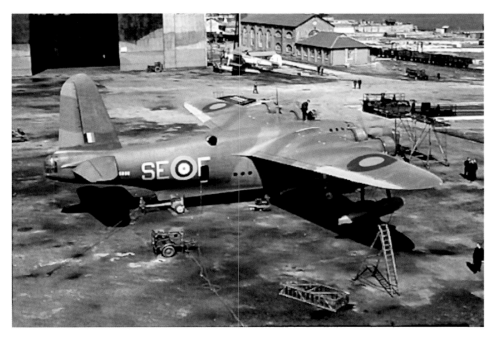

Sunderland Mk1 of No. 95 squadron at Pembroke Dock.

Pengam Moor, Splott, Cardiff

RAF Pengam Moor (or RAF Cardiff) was originally Cardiff Municipal Aerodrome. The aerodrome was situated some two miles from city centre on semi-marshland between a housing estate and the sea. The aerodrome which was initially known as Splott Aerodrome (the name was dropped in 1936) was opened for commercial flying in September 1931.

The first scheduled service from the aerodrome was on 11 April 1933 by a Great Western Railway Air Service, Westland Wessex G-AAGW flight to Plymouth. In September, Western Airways operated a service to Weston-Super-Mare. Both companies continued to operate services up until 1939. During the early 1930s the aerodrome consisted of a few wooden buildings, a basic small hangar and a grass strip.

On 1 June 1937, No. 614 (County of Glamorgan) Squadron was formed at the aerodrome with Hawker Hinds and Hectors and was used in an Army co-operational role. Between 1937 and 1939 the squadron operated from both Pengam Moor and RAF Llandow. When the Air Navigation (Restriction in Time of War) Act became law in 1939, the aerodrome was requisitioned by the Air Ministry and was renamed RAF Pengam Moor. Further wooden huts were built as part of the RAF camp. It was not until 1941 that a new Bellman was built to replace the hangar damaged in an air raid on 27 February. Also, a Sommerfield track way was laid to overcome the serious water logging and in 1942 a new 2,800-foot concrete runway was laid.

The first unit to be based at the airfield was No. 8 Anti-Aircraft Co-operation Unit in November 1940, equipped with Blenheims, Dominies and Lysanders. The unit remained at Pengam Moor until it was disbanded in December 1943. Also Nos 286 and 587 squadrons were based at the airfield between 1942 and 1944.

In February 1940, No. 43 Maintenance Unit was formed at Pengam Moor. The unit was responsible for preparing and packing aircraft for transportation abroad. During the war the MU handled most of the RAF single engine aircraft, until it closed on 30 October 1945. The MU was situated south-west of the concrete runway joined by a track way. It had five Bellman hangars and associated workshops.

Between August 1948 and July 1953 No. 3 Reserve Flying School was stationed at the airfield after its formation there, and was equipped with Tiger Moths, Ansons, Oxfords and Chipmunks.

Although wartime restriction was lifted in December 1945, regular passenger services did not start until 1948, mostly by Cambrian Airways. However, with the introduction of newer and heavier aircraft, Pengam Moor was found unsuitable for safe civilian operations and most airlines moved to the new airport at Rhoose, so Pengam Moor closed on 1 April 1954.

Today, there is hardly anything left of the airfield; most of the land is covered by grass land, two housing estates and a supermarket. There are still few buildings left on 43 MU site including four Bellman hangars which are occupied by light industry. One Bellman hangar was demolished in the 1980s.

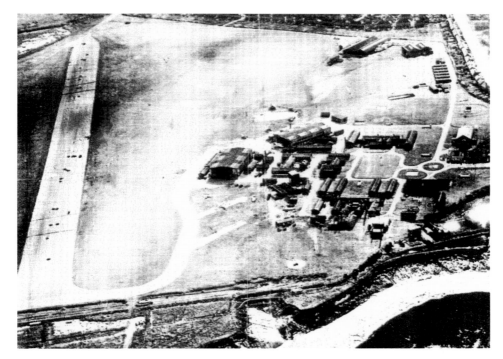

Oblique photograph of Pengam Moor (RAF Cardiff) taken in 1944.

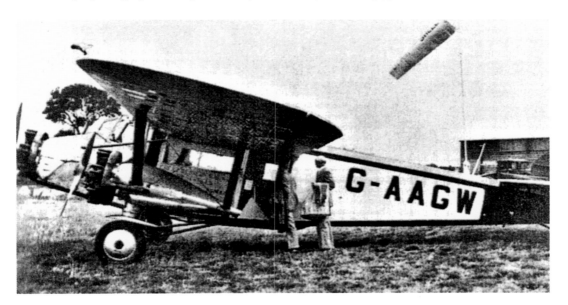

The first scheduled service from Pengam Moor took place in 1933 by a Westland Wessex.

Cambrian Air Service DH Rapide at Pengam Moor aerodrome.

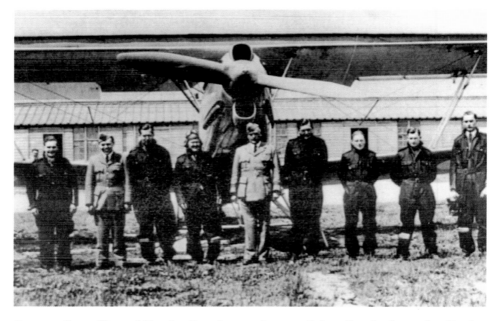

Commanding officer of No. 614 Squadron and some of the pilots in front of a Hawker Hector at Pengam Moor.

Penrhos, Gwynedd

The RAF camp at Penrhos was opened on 1 February 1937 as No. 5 Armament Training Station using the nearby gunnery range at Hells Mouth. It was situated on the Llyn Peninsula about three miles west of Pwllheli, just off the A499 Abersoch road. The airfield was a circular grass area in design built on a low plateau; the south-west boundary was some ten feet above the surrounding fields. During construction there was an arson attack on the camp by individuals opposed to the airfield, but only minimal damage was done.

The airfield had three landing areas of about 2,580 feet with a concrete perimeter track around the outskirt of the field. The main camp, the communal area and the 'school buildings' (the training huts) were located to the north of the airfield. Other buildings were scattered around the perimeter track. Initially, the airfield had an F type and a Bessoneau hangar; the latter was replaced by two Bellmans in 1939. During 1940/41 another Bellman and nine blister hangars were built around the perimeter.

The first aircraft to occupy the site were five Westland Wallaces of No. 5 ATC and during the next few years several fighter squadrons attended courses at the school. Between 1939 and date of closure various different aircraft equipped the training units.

Following enemy bombing raid on the airfield and surrounding area in 1940, detachments of fighters were eventually based at Penrhos. This continued more or less until Llanbedr and Valley became operational. No. 9 OAFU was disbanded in June 1945. Following this the airfield was used briefly by an air holding unit until March 1946. RAF Penrhos finally closed on 31 March 1946 and the site was disposed of in the 1950s. A large section of the camp became a home for Polish ex-servicemen although today they have been re-housed or returned home. All the hangars have been removed but a large number of huts still remain. Today, the technical site and the hangar area are occupied by a touring caravan camp and the airstrip is used by private light aircraft.

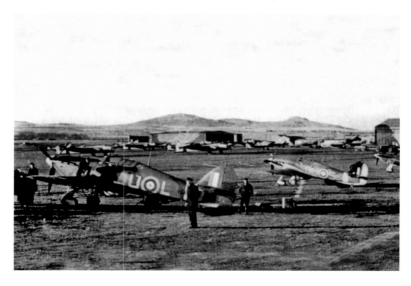

No. 312 Squadron
Hurricanes at Penrhos.

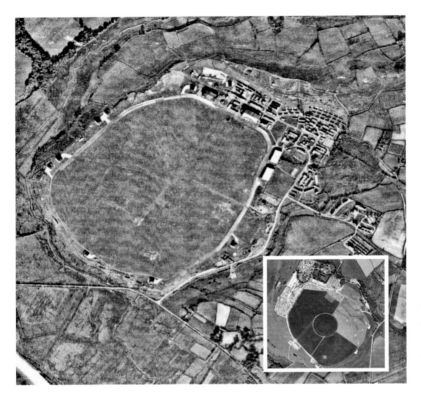

Vertical view of Penrhos airfield in 1946. *Inset:* Penrhos airfield as it is today.

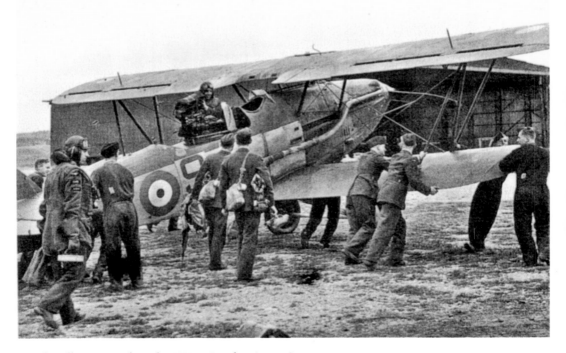

Man handling an Audax of 5 FTS at Penrhos in 1938.

Rhoose, Cardiff Wales Airport, Vale of Glamorgan

The Air Ministry requisitioned land near the village of Rhoose, some two miles from the airfield at St Athan and twelve miles from the city of Cardiff. The new airfield was built 1941/42 as a satellite to nearby Llandow, which by 1942 had acute storage problem.

RAF Rhoose had an unusual cross-shaped runway configuration with the perimeter track forming a square around the airfield. There were four Over blister type hangars with the support buildings situated on the south-east corner. Most of the other accommodation and administration building was to the east of the airfield. The first aircraft to use the airfield were Spitfires and Miles Masters of No. 53 OTU on 7 April 1942. In 1944 No. 7 Air Gunnery School with 23 Ansons and 20 Martinets moved from Stormy Down while the base was being repaired. After No. 7 AGS left in August 1944 the airfield was put on care and maintenance. However, it was eventually transferred to No. 40 Group Maintenance Unit for aircraft storage and in 1946 Rhoose became a sub site for No. 214 MU at Newport and used for bomb storage. In 1948 the airfield was closed and was handed over for civil use in 1949.

In 1950, the site was chosen as Cardiff Airport replacing the Municipal Aerodrome at Pengam Moor which was inadequate for future development. After modest redevelopment all civilian flights were transferred to Rhoose on 1 April 1954. Ex-RAF buildings were utilised as passenger terminals, offices, and departure and arrival areas until a complete new infrastructure was built.

The Welsh airline Cambrian which had operated from Pengam Moor made its base at Rhoose and continued to build up its route network. The new owners Glamorgan County Council invested a substantial amount into a new terminal, a control tower and lengthening of the main runways. Work was completed in 1972 and the facility was opened by the Duke of Edinburgh. To attract international airlines the airport adopted the name Cardiff Wales Airport.

During 1989–90 a multi-million pound expansion and improvements took place, which included extensions to the international pier with two new 300-seat passenger lounges, refurbished departure lounge and the installation of air bridges. The check-in halls were remodelled enabling more space for baggage handling. In 1990 the main runway (12/30) was further extended to 7,732 feet.

Over the years several airlines have tried, mostly unsuccessfully, to introduce scheduled services between Cardiff and the rest of Wales. There was Air Wales, Welsh Airways and more recently the new Air Wales, although sadly all have failed. In May 2007 Highland Airways operated a subsidised daily service between Cardiff and Valley on Anglesey, but in 2010 Manx2 took over the route.

British Airways has built a large engineering complex at the north-western edge of the airport, capable of handling Boeing 747 aircraft, which was opened in 1993.

In 1995 the airport was privatised and was taken over by TBI plc.

In 2006 the owners invested £7 million in upgrading the airport facilities including a floor walkway – the first in the UK – a new departure gate and a general refurbishment of other structures.

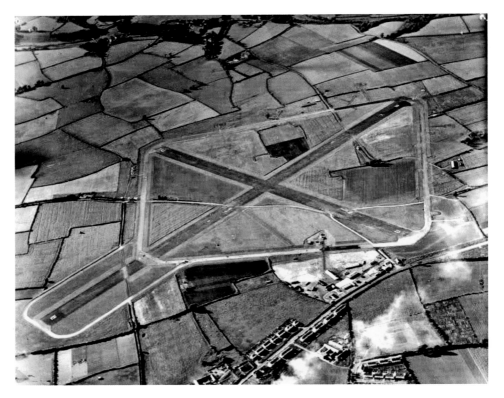

An unusual runway layout at Rhoose airfield.

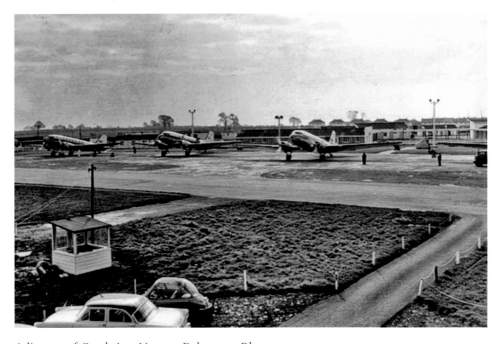

A line up of Cambrian Airways Dakotas at Rhoose.

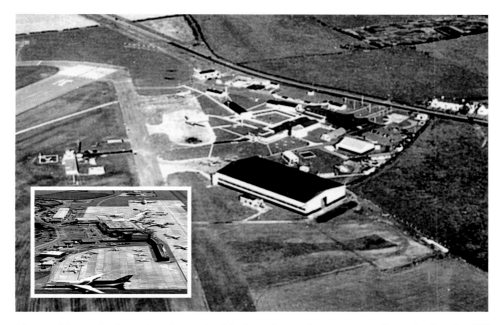

Rhoose Airport in the 1960s. *Inset:* Aerial view of a modern apron and terminal at Cardiff International Airport.

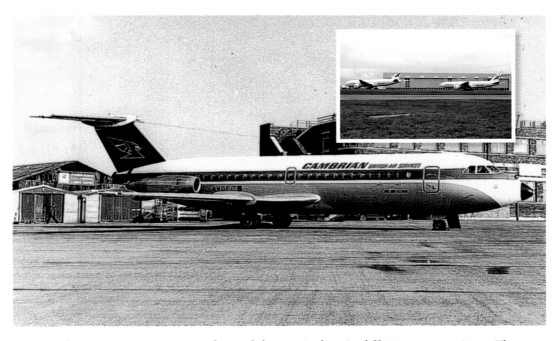

Cambrian Airways BAC 1-11 in front of the terminal at Cardiff Airport, 1971. *Inset:* The British Airways maintenance hangar at Cardiff Airport.

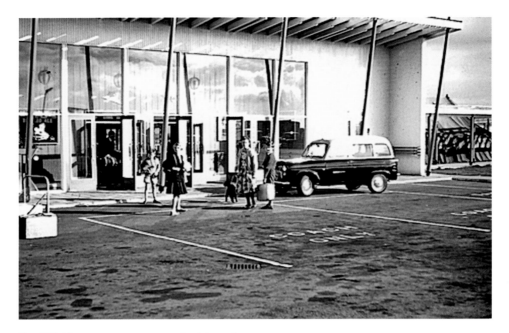

Cardiff Airport passenger terminal in 1960.

Entrance to the modern terminal at Cardiff Airport today.

St Athan, Vale of Glamorgan

The site situated alongside the B4265 and seven miles from Barry was acquired in 1937 and by November 1938 it had been allocated to Maintenance Command because of its expansion possibilities. The airfield took eighteen months to complete and was opened on 1 September 1939. Initially, the airfield was to have one concrete runway, but in 1939 another was built. In 1944 both runways were lengthened to accommodate the four-engine bombers entering service.

The base was divided into two camps, East Camp and West Camp, with hangars, accommodation blocks, administration facilities and various messes. Both camps were self-contained.

The first unit to be formed was No. 4 School of Technical Training at East Camp. The civilian manned No. 19 Maintenance Unit, which was an aircraft storage unit responsible for storing aircraft in operational readiness, was formed on 7 February 1939. In early 1940, there were 280 Fairey Battles and Hawker Hurricanes stored at the MU. Later in the year they were joined by Bristol Blenheim Is, Westland Lysanders and Boulton Paul Defiants, which brought the total by September to nearly 700 aircraft. Later in the war, types of aircraft changed to include Spitfires, Wellingtons, Mosquitoes and the Avro Lancaster, a four-engine bomber. Storage became an acute problem so an area between St Athan and the nearby airfield at Llandow was used. Both airfields were connected by a metal taxiway.

On 1 December, No. 32 MU was formed at St Athan for fitting electronic equipment in aircraft as well as aircraft repair.

For air defence of the base six Hurricanes from No. 11 Group Fighter Pool arrived on 27 June 1939, and were later were joined by another sixteen Hurricanes plus eleven Battles. The unit moved to Sutton Bridge in March 1940 to become the nucleus of No. 6 OTU. Also in September 1939 the School of Navigation equipped with nearly 100 Ansons became resident. In June 1940, it was re-named No. 1 ANS and moved to Canada. Another interesting unit formed at St Athan was 'U' Flight of No. 1 Anti-Aircraft Co-operation Unit in August 1940 as a pilotless aircraft section equipped with Queen Bees.

On 1 September 1943, No. 12 Radio School was formed at the airfield; the unit was responsible for conducting radar training for maritime patrol aircraft. It was joined in June by No. 14 RS, which brought the total establishment to forty-two Ansons and Oxfords plus twenty-one spare aircraft.

The first Luftwaffe raid on St Athan was in August 1940 when a lone bomber dropped bombs on the grassed area of the airfield. However, on 29 April 1941 at least twelve German Ju88s dropped a cluster of incendiaries and high explosive bombs on the hangars. Damage was minimal, although three Hurricanes were destroyed and other aircraft were damaged. The next attack on 11 May caused three fatalities and damaged two hangars.

By September 1944 there were a total of forty-six hangars located around the site including twenty Bellmans, two 'D' types, six earth covered 'E' types, four 'C' types and at least twenty Robin and Super Robin hangars. Also there were four large hangar workshops used by No. 32 MU and No. 4 S of TT.

In the post-war era both the MU and the S of TT remained at St Athan and continued to evolve in the ever changing needs of the RAF. The airfield became one of the most important bases for support, training, repair and storage facility in the RAF. It was involved in the maintenance of Britain's V bombers – the Valiant, the Victor and the Vulcan. Ironically, most of these were broken up at the MU. Other aircraft handled at the base ranged from Lightnings to Phantoms and Tornadoes, from Hawks trainers to the Harriers. It became a major maintenance base for the RAF transport aircraft such as the Tristar and VC10 tankers.

Gliding has always played an important aspect in the life of the station since 1947, firstly with No. 68 Gliding School and then with No. 634 Volunteer Gliding School.

In 1963, St Athan became an Aircraft Supply and Servicing depot for the three services and in 1968 the MU was disbanded and replaced with three wings: Aircraft Engineering Wing, General Engineering Wing and the Engineering Plans and Development Wing. All engineering aspects came under Defence Aviation Repair Agency (DARA). In March 2002 the Ministry of Defence reallocated DARA to one area of the airfield (East Camp) where a state-of-the-art engineering centre with hangar space of 65,000 square metres was built as Project Red Dragon which was opened on 14 April 2005. In 2006 the airfield was renamed MOD St Athan. Further expansion was announced including the plan for St Athan to become a Defence Technical College for the three services, but in 2010 the project was cancelled.

Over the last few years there has been a great deal of uncertainty about the airfield, although it has been confirmed that it will remain an engineering establishment in some form for the service.

Today, the RAF School of Technical Training remains at the airfield providing skilled mechanics for the twentieth century. The 1st Battalion of the Welsh Guards moved their base from Aldershot to St Athan's West Camp.

The general layout of the airfield has changed since the war years. Most of the wooden huts have been replaced by brick buildings. Many of the hangars remain although the Robin hangars have been demolished. Only one of the runways is in use, 08/26. Perhaps the airfield's best land mark – the water tower – was demolished in 2011.

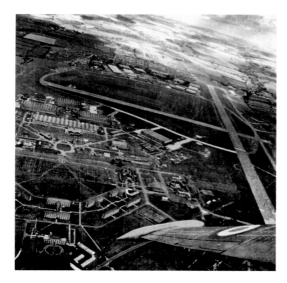

A St Athan aerial view, 1962, showing both the east and west camps clearly.

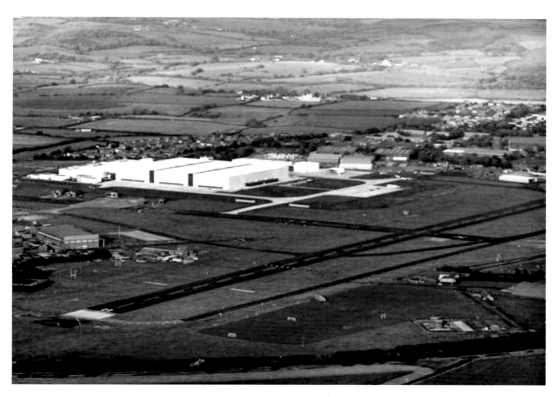

MOD airfield at St Athan in 2011 showing the redevelopment.

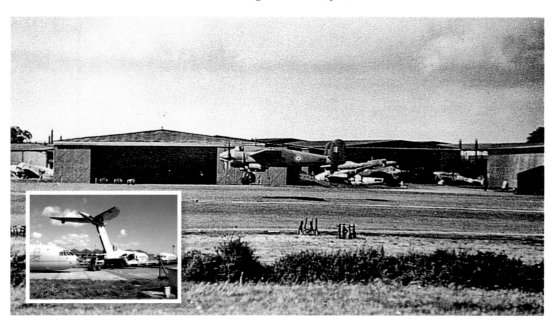

A Bristol Buckingham landing at St Athan for disposal in the early 1950s. *Inset:* VC 10s at Breakers Yard at St Athans.

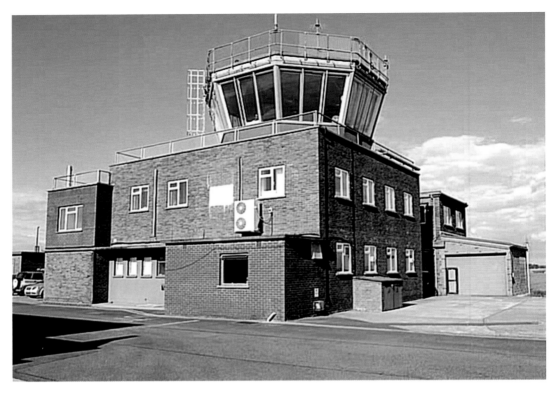

St Athan control tower.

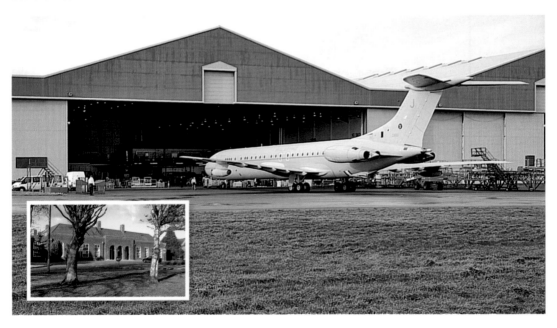

VC 10 at DARA St Athan for maintenance at the hangars built for the Red Dragon project.
Inset: The brick-built officers' mess and education section at St Athan.

St David's, Pembrokeshire

The airfield was situated just off the A487 Haverfordwest to St David's road, a mile from the village of Solva. Approval was given in September 1941 for the acquisition of land near St David's for the construction of an airfield as a satellite for Haverfordwest. Most of the construction took place throughout 1942 and was opened in September 1943 as part of RAF Coastal Command chain of coastal airfields.

The airfield had three 150-foot-wide tarmacked runways – 08/26 was 5,910 feet, 04/22 was 3,200 feet and 13/31 was 3,570 feet respectively. Along the perimeter track there were thirty diamond-shaped hard standings in clusters of five. The main site including the technical site, administration, crew huts, sick quarters and the control tower was situated to the south, more or less in between runways 04 and 31. All accommodation and mess rooms were in fields leading off the main site. Two of the airfields T2 hangars were situated on the main site, while the other was between approaches to runways 26 and 31. Initially, the airfield was planned to have four hangars and a number of blister types but only three T2s were built, although the base for the fourth was laid and was used for additional parking. The station bomb and fuel dumps were located to the north of the airfield. All buildings were either Maycrete or Nissen types.

Although intended for use by the US Navy for anti-submarine patrols the first RAF unit to be based at the new airfield was Handley Page Halifax of No. 517 Meteorological Squadron on 26 November 1943. This was joined by another two Halifax units, Nos 58 and 502, in December. The squadrons were involved in meteorological, anti-submarine and convoy patrols. Due to over-crowding No. 517 Squadron moved to Brawdy in February 1944 followed by the other two Halifax squadrons in September. A detachment of Boeing Fortresses II of Nos 206 and 220 squadrons also arrived in December 1943.

St David's airfield was not really suited for four-engine operations due to the alignment of the runways with the prevailing winds, which restricted the aircraft taking off fully loaded. Usual procedure was to take-off from St David's with a light fuel load and then land at nearby Brawdy to top up the fuel tanks. Because of this drawback St David's airfield was relegated to satellite and Brawdy became the main base.

Between June and September 1945 Liberators of Nos 53 and 220 squadrons was based at St David's. On 1 November 1945 station headquarters and all associated sections moved to Brawdy and the airfield was put on Care and Maintenance.

On 1 January 1946 both St David's and Brawdy were taken over by the Admiralty for the Fleet Air Arm. The former acted as a relief landing ground to Brawdy.

From 1950 the airfield became the base for Fleet Requirements Unit (FRU) operated by Airwork Limited and equipped with Sea Hornet NF21s and Mosquito T33s and eventually Gloster Meteor T7s. Also in 1952, No. 587 RN Squadron with Supermarine Attacker FB 1 was based at the airfield. With the introduction of heavier jet aircraft the airfield was regarded as obsolete.

The RAF took over the tenure of Brawdy in 1971 and used St David's as a relief landing ground. During which, runway 08/26 was resurfaced and the three T2 hangars were dismantled and re-built at Brawdy. When RAF Brawdy closed St David's airfield was disposed of and most

of the site was taken over by the Pembrokeshire Coast National Park Authority. In 2002 the airfield was used as the site for the National Eisteddfod of Wales.

Today, the remains of the runways, dispersal bays and perimeter track are still extant, but are breaking up quickly. The few remaining buildings left are used by local farmers.

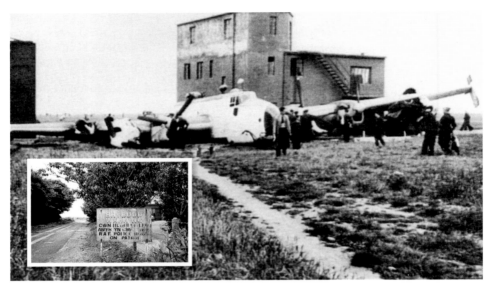

A crash landing of a Halifax of No. 517 Squadron at St David's. *Inset:* Today there is hardly any airfield infrastructure left at St Davids. This was the original main entrance.

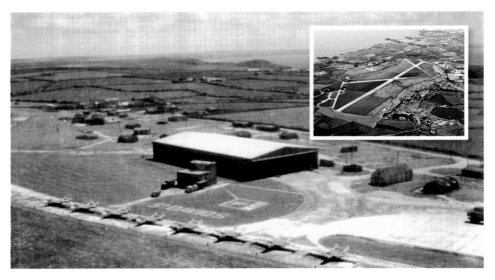

A 1963 photogrpah of a neat line up of DH Sea Vampires of No. 863 Squadron. *Inset:* St Davids airfield from the air, taken in 2000.

Sealand, Shotwick/Queensferry, Flintshire

The site of Sealand comprised of two First World War airfields, Shotwick and Queensferry, which were adjacent to each other, only divided by the railway line. The two airfields were developed separately, Shotwick as a training station and Queensferry as an Aircraft Acceptance Park. Shotwick came into being in 1914 with the building of accommodation huts, various messes and six 170 feet by 100 feet aeroplane sheds, with brick walls and timber roofs. Further workshops and associated buildings were added later as well as a drained landing area of approximately 3,000 feet. In total the aerodrome occupied an area of 165 acres. Queensferry was developed as an acceptance park with nine 300 feet by 170 feet hangars in groups of threes, positioned to the east of the aerodrome south of the main site at Shotwick. The Aircraft Acceptance Park was not completed until the end of the war and was only fully utilised in the 1920s.

RAF Shotwick became a premier training establishment for the Royal Flying Corp. The first training units to arrive at the station were No. 95 Squadron in October 1917 followed by No. 96 a few days later. Both were equipped with various RFC standard fighters of the time. Both squadrons remained at Shotwick until July 1918. Several other squadrons also used the aerodrome during the war including Nos 61 and 90 squadrons.

On 2 August 1918 the site at Shotwick was renamed North Shotwick, whilst Queenferry site was known as South Shotwick.

On 1 April 1920 several training units were amalgamated forming No. 5 Flying Training School equipped with Avro 504s at North Shotwick. The station was renamed RAF Sealand in 1924. Throughout the 1920s RAF Sealand continued to train pilots for the Royal Air Force. In 1927 considerable redevelopment took place, most of the wooden huts were replaced by permanent brick-built accommodation blocks, various messes and school rooms. On 23 May 1929 the RAF Packing Depot moved from Ascot to South Camp at RAF Sealand and remained there throughout the Second World War.

In the 1930s several Empire Air Days were held at the aerodrome giving local people an opportunity to see the RAF at its best. On 15 October 1936 No. 36 MU was formed at Sealand as a packing depot followed in July 1939 by No. 30 MU, which was responsible of fitting AI radar to Beaufighters and the conversion of seventy Havocs into Turbinlite aircraft. Due to an acute storage problem, No. 5 FTS moved to Tern Hill in July 1939. The next training unit to be based at the airfield was No. 57 OTU equipped with Oxfords and initially with Miles Masters replaced later by Spitfires. The OTU was responsible for providing specialising training to airmen before being posted to an operational unit. No. 53 OTU left in January 1941 and over the next few years several other training units were based at the airfield, the last to leave was 24 Elementary Flying Training School in 1946.

In March 1951 the site was handed over to USAAF, 30 Air Depot Wing, who remained there until 1957.

On 1 February 1959 No. 30 MU was reformed at Sealand to become the main military avionics base in the country. In the early 1980s a new £5.1 million avionics workshop was built for the three services on the East Camp. In 2002, DERA took over full control of the MU and within three years RAF Sealand (service side) closed. DERA continued to run the site until 2006, when it became MOD Sealand with the Defence Support Group taking over part of the site.

West Camp eventually had six General Service (GS) sheds in three groups of two, one 'C' type, four Bellman, one A1 and eighteen various blister type hangars. There was a north/west to south/east concrete runway 3,960 feet long. On south camp there were nine GS hangars, two 'C' type and two 'L' type storage hangars.

Today, the west and south site are used as an industrial estate while the hangars, some of which have been refurbished, are used for storage and workshops.

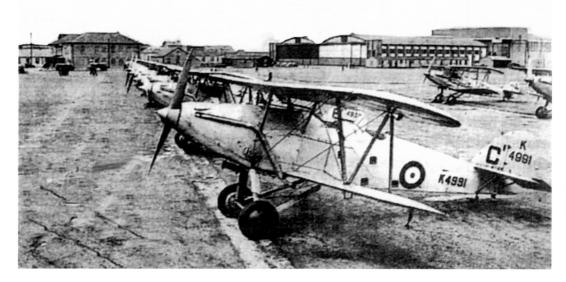

Hawker Harts of 5FTS on Empire Air Day at Sealand in 1938.

Sealand camp in the 1920s.

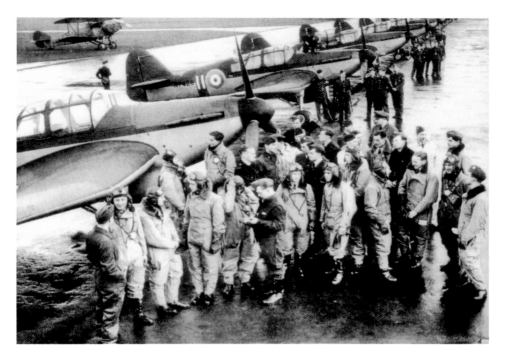

Pilots and students of No. 5 FTS Sealand.

RAF Sealand today. Most of the hangars are part of the business park. *Inset:* A Sealand aerial view taken in 1946.

Stormy Down, Vale of Glamorgan

RAF Stormy Down was situated two miles north-east of Porthcawl. Initially, the site was surveyed in early 1934 as a possible site for an aerodrome or a military camp. Work on the site began in 1938 and was officially opened in June of the following year. The airfield consisted of a grass landing area with four reasonable landing strips of around 3,000 feet each. There was a narrow concrete perimeter track around the landing area. The main technical site included four Bellman, an 'F' type, a Bessoneau, an SP and five blister hangars. Four blister hangars were at the southern end and one added later on the west side. Most of the main camp including accommodation huts, school rooms, administration and mess halls were located in row of wooden huts behind the hangars. Due to poor drainage the landing area was frequently water logged and flying had to be suspended. After a series of accidents involving aircraft undercarriages, the landing area was levelled, properly drained and pierced steel planking was laid.

The first unit to be based at Stormy Down was No. 7 Bombing and Gunnery School in November 1939, equipped with twenty-four Whitley and thirty-four Fairey Battles. These were later replaced in 1942 by Lysanders and Defiants. During 1944 the unit's establishment, which had been renamed Air Gunners School, was thirty-seven Ansons and twenty-eight Martinets. By the end of the year the RAF requirement for air gunners had declined and, therefore, No. 7 AGS was disbanded in September 1944. For a brief period No. 40 Initial Training Wing was set up to train French airmen, but this was disbanded in November and Stormy Down was put on Care and Maintenance. The airfield closed in July 1945, but remained under the control of the Air Ministry until 1946.

Over the years parts of the camp has been used for police driver training and for karting. The narrow perimeter track still exists as well as the foundations of most of the wartime camp. Until the early 1980s there were a number of brick buildings scattered around the airfield, but most of them have been demolished except for the water tower, the F type hangar and the double Bellman hangars, which have been refurbished and are used for storage.

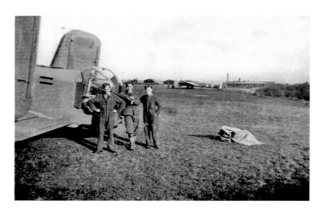

Whitley's of No. 7 Bombing and Gunnery School at Stormy Down.

Talbenny, Pembrokeshire

Talbenny airfield was situated on an escarpment overlooking St Bride's Bay some three miles from Dale airfield. It had three concrete and tarmac runways of 4,800 feet, 3,300 feet and 3,000 feet with a central intersection, and thirty-six 'frying pan' type hard standings, sufficient for the parking of two fully equipped squadrons. The technical site was situated on the northern end of runway 03/21, while the communal site was off the B4327 Haverfordwest road. The airfield had two T2 hangars built apart, one in the main technical area on the north-east corner and the other on the south-east corner of the airfield.

The airfield officially came to existence on 1 May 1942 under No. 19 Group, RAF Coastal Command, with Dale to the south as its satellite station. The first squadron to be stationed at Talbenny was No. 311, a Czech manned bomber squadron equipped with Vickers Wellington ICs, and was involved in anti-submarine patrols and enemy shipping strikes in the Bay of Biscay and the Western Approaches. To provide fighter cover for the Wellingtons detachments of Beaufighters from Nos 235 and 248 squadrons were also based at Talbenny in January/February 1943.

Shipping strikes came to an end in May 1943 and No. 311 Squadron left Talbenny and returned to Bomber Command. No. 4 Armament Practice Camp equipped with Miles Martinets target towing aircraft was formed at the airfield in April 1943 and remained at Talbenny until September 1945. On 11 October 1943 the airfield was transferred from No. 19 Group Coastal Command to Transport Command with No. 16 Flight moving in with various aircraft. Coastal Command Ferry Training Units also became residents at the airfield. In September 1944 the unit was merged with No. 3 Overseas Despatch Unit to become No. 11 Ferry Unit and was tasked with training crews for Warwicks, Wellingtons, Venturas, Ansons and Oxfords but left for Dunkeswell in August 1945. The airfield was finally closed on 23 December 1946.

In the 1950s the airfield's accommodation and other communal site was used by the Ministry of Agriculture to accommodate volunteer harvest labourers who were helping in local farms. Most of the airfield's infrastructure including the hangars were demolished in the late 1950s/early 1960s. Sections of the runways were also broken up and land returned for farming although the airfield layout is still visible from the air. There are still some of the technical site buildings; the operations block and various buildings on the communal site are still standing and in use today.

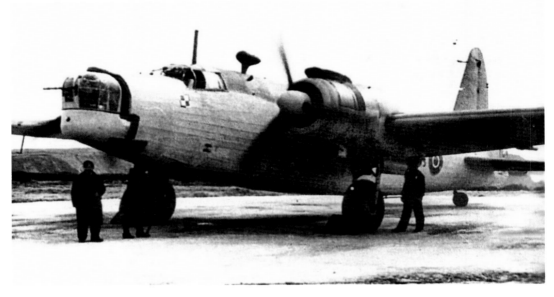

No. 304 Squadron Wellingtons operated with No. 311 from Talbenny in November 1942.

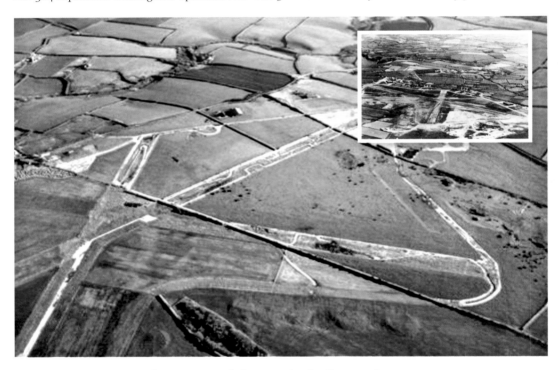

Talbenny aerial photograph. *Inset:* Aerial photograph of Talbenny taken in 1945.

Templeton, Pembrokeshire

Land was requisitioned near the village of Templeton in 1941 for the construction of an airfield to act as a satellite to Haverfordwest. The airfield was wedged between the A4115 and the A4075 roads. Most of the construction took place during 1942 and was officially opened in January 1943. It had three concrete and tarmac runways: 12/30 was 3,300 feet, 18/36 was 3,000 feet and the longest 07/25 was 4,800 feet. Most of the dispersal pans were situated to the north and west of the runways. The main camp including workshops, training schools, administration, watch office and the sole T2 hangar was just off the A4115 road with No. 1 site on the other side of the road. The airmen and WAAF accommodation sites were dispersed in adjoining fields. Location of the airfield was questionable as situated in the middle of the triangular runway layout was a hill which obscured all-round vision.

Construction of the airfield was temporarily suspended as no RAF command had an immediate requirement for the site. However, as Withybush (Haverfordwest) had acute parking problems it became a satellite for the airfield.

The first unit to be based at Templeton was No. 306 Ferry Training Unit with twenty plus Bristol Beauforts, but in March the unit moved to Northern Ireland. The next unit to move from Haverfordwest was No. 3 Coastal Operational Training Unit with Ansons, Wellingtons and a few remaining Whitleys. The OTU remained at Templeton until it was disbanded in January 1944. During the summer of 1944 the airfield was often used by Martinets and Spitfires of No. 595 Squadron from Aberporth during their towed target glider trials. Between February and June 1945 a small engineering section from Haverfordwest remained at Templeton for the maintenance of No. 8 OTU aircraft. When the unit left for RAF Benson in June 1945 the station more or less closed but remained under Haverfordwest.

The airfield was finally sold in 1960 but was leased back by the Ministry of Defence shortly afterwards and is used as a Dry Training Area for various equipment trials. There is very little of the wartime buildings left and most of the airfield is obscured by vegetation.

This firing butt at Templeton has since been demolished.

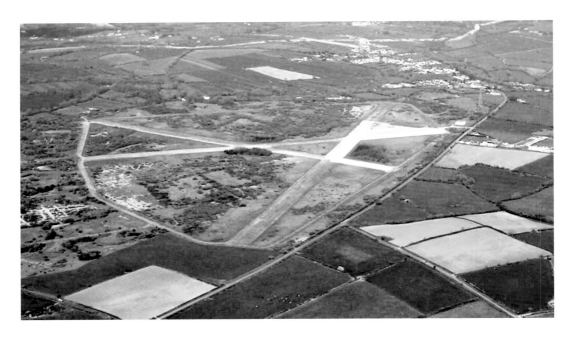

Templeton airfield as it is today.

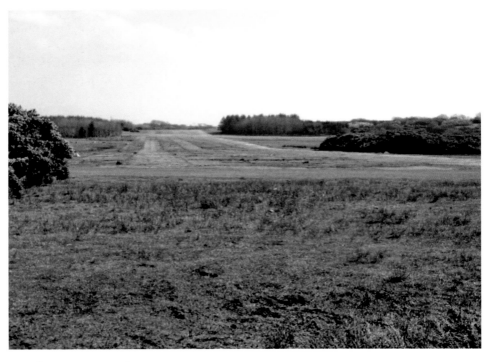

Templeton runway today.

Towyn, (Tywyn) Gwynedd

RAF Towyn was situated on land known locally as Towyn Morfa, just off the A493 coast road, overlooking the inlet of Aber Dysyni. The camp was built to support the Anti-Aircraft Practice Camp at nearby Tonfanau. The airfield was opened on 8 September 1940 within No. 70 Group, Army Co-operation Command.

The site had three grass landing areas of 3,900 feet, 3,600 feet and 2,100 feet. In the north-east corner was Camp Matapan, the Royal Marines LCT School. RAF Towyn main site was on the southern end near the railway line with No. 5 site which included the WAAF barracks to the east. The airfield had two Bellman hangars with adjoining concrete apron, two blister hangars and two Bessoneau hangars which were the first to be built. The HQ, mess rooms, sick bay, school rooms and workshops were situated together on the main site; all were either Maycrete type or wooden construction.

The first unit to be based at Towyn was 'U' Flight of No. 1 AACU equipped with Queen Bee target aircraft in October 1940 and was later joined by Hawker Henleys of 'C' Flight from Penrhos. The two flights were renumbered on 1 December 1943 to become No. 631 Squadron. The squadron was eventually re-equipped by Miles Martinet target towing aircraft. The unit moved to Llanbedr on 10 May 1945, which had concrete runways.

The airfield was often used as a diversionary landing ground. Perhaps the most interesting occurrence was when twelve P38 Lightnings of the USAAF 97th fighter squadron were forced to make an emergency landing, while on a flight from Northern Ireland to North Africa. The most dramatic emergency landing took place on 8 July 1944 when a Boeing B17 Flying Fortress (942.31321 CC-M) made a landing, coming to rest just over the railway line.

RAF Towyn was officially closed on 25 July 1945, but in the post-war period was briefly used as an Army camp (Morfa Camp).

Today, the hangars and the WAAF site have been demolished, but several buildings on the main headquarters site are still intact and are in use.

A USAAF B-17 overshot the runway at Towyn.

Pilot Officer G. Probyn and Corporal L. Ptt of C Flight 1 AACU in front of their Hawker Henley.

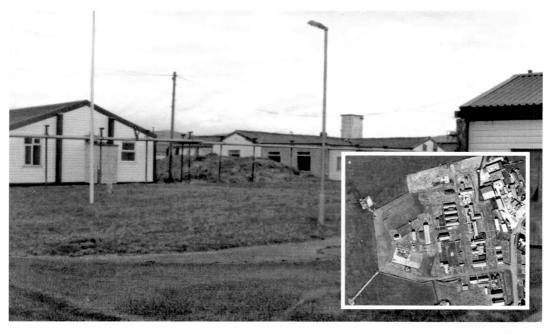

The remaining buildings at RAF Towyn today. *Inset:* RAF Towyn main camp in 2010.

Valley (Rhosneigr), Anglesey

Valley is the only operational military airfield in Wales today. It was built in 1940 as a fighter base to cover shipping and for the protection of industrial areas and Merseyside ports. Initially called RAF Rhosneigr, it was built on the sand dunes and marshy land overlooking Cymyran Bay.

The airfield had three concrete and tarmac runways of 4,800 feet, 4,200 feet and 3,900 feet; all three have been extended several times since the war. The main technical site was situated on the north-east corner near the railway line. In 1941, the airfield consisted of two T2s, three Bellman's and four blister type hangars. By 1944 another T2 and five blister type hangars were added. The communal sites were dispersed on the northern side of the railway line and on either side of the nature reserve.

RAF Rhosneigr was opened for No. 90 Group fighter Command on 1 February 1941, but on 5 April changed its name to RAF Valley. The first fighter unit to be based at the airfield was a detachment from No. 312 (Czech) Squadron with Hawker Hurricanes. Over the next few years several fighter squadrons equipped with Hurricanes and Spitfires provided air defence from RAF Valley. To cope with an ever-increasing night raids in the vicinity great emphasis was placed on night fighter cover. The first unit to be based here was Bristol Beaufighters IF of 'A' Flight of No. 219 Squadron followed by No. 68 Squadron.

On 30 June 1941 No. 456 (RAAF) Squadron was formed at Valley, initially equipped with Defiant Mk Is, but was later re-equipped with Bristol Beaufighter IIs. The squadron remained at Valley until 30 March 1943 and was replaced by Beaufighters and Mosquitoes of Nos 125 and 157 squadrons.

In 1943 the airfield was transferred to USAAF Ferry Terminal which became operational on 19 June. The airfield was involved in American aircraft movement between Britain and the States. Over 2,600 USAAF bombers of all description passed through the airfield each carrying up to twenty servicemen returning home. Aircraft of both Nos 125 and 157 squadrons provided escort and acted as 'shepherds' to aircraft that were lost or in trouble. The USAAF Movement section closed in September 1945 and total control of Valley returned to the RAF.

In the post-war period the station was gradually run down, although in 1946 No. 10 Air Gunners School was re-formed at Valley with Masters and Wellingtons but was disbanded the following year. From 1947 to 1951 the airfield was put on Care and Maintenance.

In 1951 RAF Valley was designated as a Flying Training airfield with No. 202 Advance Flying School being formed in March equipped with DH Vampire FIs, FB5s, TIIs and Gloster Meteor T7s. In January 1954 it was joined by No. 206 AFS and in March was renamed No. 7 Flying Training School to be renumbered No. 4FTS in 1960. Over the years type of training aircraft has changed from Hunter T7s and Folland Gnat T1s to BAe Hawk T1s and T2s in 1976, which are the RAF standard trainer today.

RAF Valley has always been linked to air-sea rescue, as during the war years it was the responsibility of a detachment of No. 275 Squadron with its Lysanders, Spitfires and Walruses. From June 1955 ASR coverage was provided by a detachment of helicopters from No. 22 Squadron. Today, the task is covered by Westland Sea kings of 'C' flight No. 22 Squadron. One of its co-pilots is HRH Prince William, Duke of Cambridge.

Another unit based at Valley between 1957 and 1962 were the Guided Weapons Development Squadron and the Guided Weapons Training Squadron equipped with Swifts and Javelins. The unit is known today as Missile Training Camp and operates aircraft from other units in missiles tests over the Cardigan Bay range.

There has been considerable redevelopment at the airfield over the years. Three of the runways have been lengthened, although only two are in use, and a new hardstand with an improved taxiway has been added. A Gaydon hangar was built on the site one of the Bellman hangars, as well as a new RAF type control tower near the original one. The main administration, sick quarters and accommodation blocks are situated just off Min-y-Ffordd road. In 2011 a state-of-the-art maintenance hangar and squadron building was built at the end of 08/26 runway to house a new training school for the RAF and Fleet Air Arm. Perhaps the most noticeable building is the new passenger terminal just off the main entrance to the camp and is known as Anglesey Airport (Maes Awyr Mon). In April 2007 a twice daily air service to Cardiff International was started by Highland Airways. Today, the service is flown by Dornier Do 228 of Manx2 Airlines.

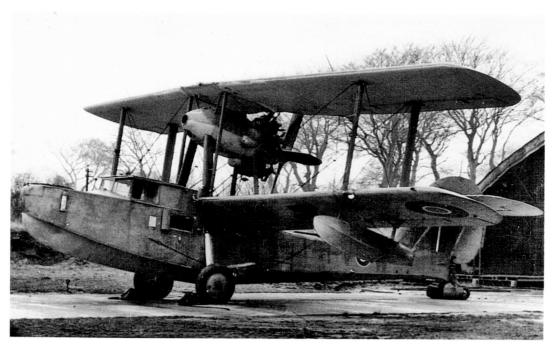

During the Second World War Walrus amphibian aircraft of No. 275 Air Sea Rescue Squadron was based at Valley.

No. 22 Squadron provides air-sea rescue cover at RAF Valley today.

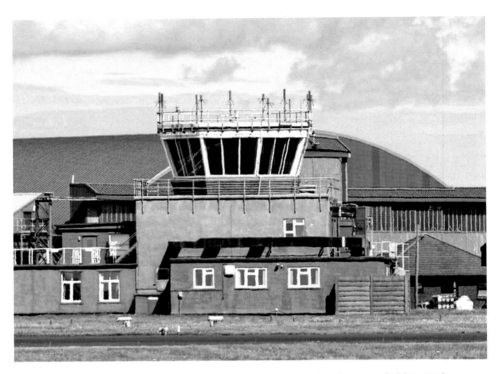

RAF Valley control tower and hangar, the only operational military airfield in Wales.

Maes Awyr Mon terminal (RAF Valley).

Wrexham (Borras), Denbighshire/Clwyd

Authorisation was given in October 1940 for the requisition of land at Wrexham for the building of a satellite airfield for Hawarden. The site chosen was on a plateau on the outskirts of Wrexham in an area known as Borras. Work began on the airfield on 16 December 1940 and was officially opened in June 1941.

The airfield had three concrete runways as it was initially intended to house a fighter squadron. However, the first unit to be based at the airfield was No. 9 Anti-aircraft Co-operation Flight on 10 August equipped with Blenheims and Lysanders. The first fighter unit was No. 96 Squadron on 21 October 1941 with fourteen Boulton Paul Defiant Is and two Hurricane IIs. The squadron was re-equipped with Bristol Beaufighter IIs in May 1942. Also in 1942, No. 285 Squadron equipped with seven Lockheed Hudsons, four Blenheims, six Lysanders and four Defiants for target towing, became a lodger unit at the airfield. Up until 1945 several other units were based at RAF Wrexham including detachments from Nos 577 and 595 squadrons and training units such as 6 AACU, 5, 11 and 17 PAFU with their various training aircraft. The airfield kept its RLG status until June 1945.

RAF Wrexham had three concrete runways: 10/28 was 4,680 feet, 16/34 was 4,050 feet and 04/22 was 3,300 feet. Off the perimeter track there were six double fighter dispersal pens on the south side of the airfield. In all there were eleven blister type hangars and a Bellman for servicing on the west side. There were four accommodation sites, two communal sites and a separate sick bay situated away from the airfield.

The airfield was put on Care and Maintenance in early 1946 and soon after was briefly used by No. 19 Fighting Vehicle Depot of the Royal Army Ordnance Corp as a show place armoured vehicles. In October 1959 the site was sold by auction to the United Gravel Company, a subsidiary of Alfred McAlpine who actually built the airfield in 1940/41. The airfield structures have been demolished except for the Bellman which is used for plant storage, while the rest of the site is excavated for gravel. The RAF accommodation area was demolished in 1960 and is now the Borras housing estate. Before the airfield was totally excavated the National Eisteddfod of Wales was held on the site in 1977.

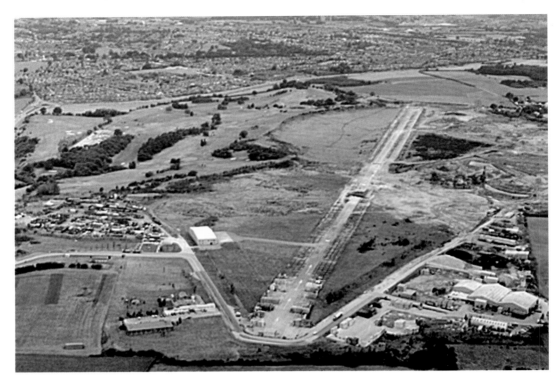

Borras Airfield used as a sand and gravel quarry.

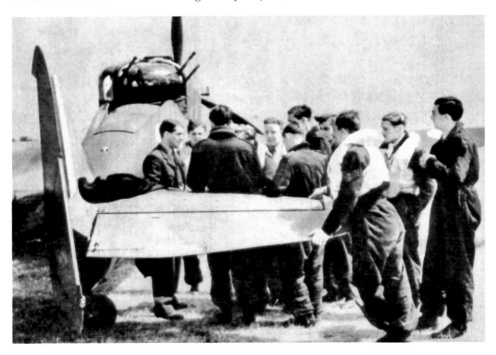

No. 96 Squadron Defiant crews discuss tactics prior to a patrol.

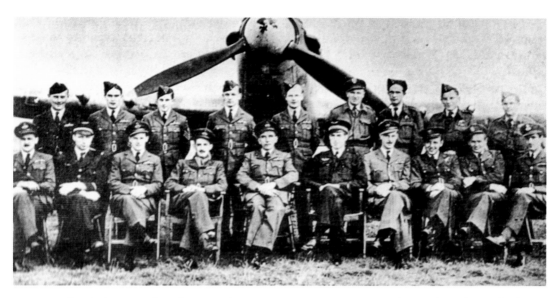

Another lodger unit based at Wrexham in 1943 was No. 577 Squadron. Pilots always had time for a group photograph.

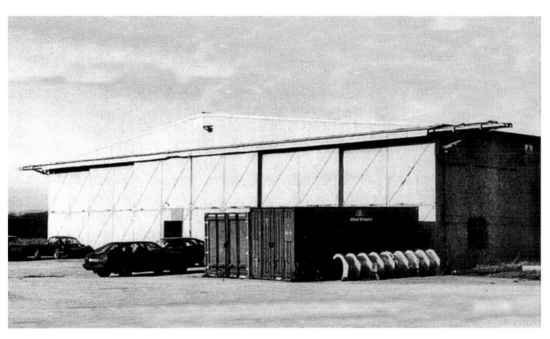

A Bellman hangar at RAF Wrexham, 1980.

Satellite Landing Grounds and Relief Landing Grounds

There were three SLGs and two RLGs in Wales, all built and used during the Second World War.

Chepstow SLG, Monmouthshire

The site was situated on Chepstow Racecourse and became operational on 13 May 1941 as No. 7 SLG under the control of No. 19 Maintenance Unit, St Athan. The site is situated between the A466 road and the River Wye, some two miles from the town of Chepstow. Most of the racecourse buildings were utilised by the station personnel including the men of the Home Guard who guarded the site.

The landing airstrip extended the length of the racecourse, and a watch tower, tractor shed and ablutions were built nearby. The aircraft were mostly parked in areas under the trees. However, several unique shields of wire wool and netting were built to protect and camouflage the parked aircraft. The first aircraft stored at the site were fifteen Spitfires and a handful of Hurricanes.

On 21 February 1943 the SLG was taken over by No. 38 MU Llandow which was experiencing the lack of storage space. During May/June 1943 the SLG had thirty-four aircraft in storage, mostly Spitfires, Mustangs and a few Bostons and Albermarle.

The SLG closed on 31 March 1945 and the within months horse racing was resumed. Today, only the watch tower and few pill boxes remain.

Rudbaxton SLG, Pembrokeshire

Rudbaxton opened as No. 4 Satellite Landing Ground (SLG) on 1 May 1941 for use by No. 38 Maintenance Unit at Llandow. The SLG was situated half a mile north-east of RAF Withybush. Parking space was limited at Llandow and the threat of air raids was ever present. The site was situated along the A40 Haverfordwest to Fishguard road consisting of a long narrow, fairly level ground with clear approaches. Fields adjacent to the strip had hedges removed for access. Also several hides were built on the eastern side. Standard buildings for an SLG were a tractor shed, a mess room, a latrine and a watch office. A private house just off the junction of the A40 and Spittal Road was requisitioned as a watch office. There is no evidence that the SLG had a hangar, but some local people reported a large shed similar to a blister or a Robin on the south-western side. Aircraft stored at Rudbaxton were Whitleys, Blenheims, Lysanders and Tiger Moths.

Today, the tractor shed, mess room and latrine remain and are used by the land owner, while the watch office is a private bungalow. Some of the hides are still visible, especially in winter. Another SLG was planned by No. 38 MU at Picton Park, adjacent to Picton Castle, but not acquired.

Tractor shed and mess room at RLG Rudbaxton today.

Haroldston West RLG, Pembrokeshire

Some 135 acres were requisitioned in 1941 from nearby Haroldston farm and Haroldston Hall for a RLG while Withybush airfield some five miles away was being built. Preparation for the landing ground was minimal, only hedges were removed and ditches filled in. Main access to the site was from the Broad Haven road with Tong Cottage at the edge of the landing area being used by personnel manning the site, whose duty involved placing markers out on the field for incoming aircraft as well as guard duties in a makeshift gun post. There is no record of the RLG ever being used, except during the summer of 1942 when a small biplane, probably a Tiger Moth or a Queen Bee, attempted to land. Also one of Carew's Ansons, on returning from a patrol, circled the strip twice but decided it was safer to proceed to Talbenny.

As more airfields became operational in Pembrokeshire, Haroldston West closed in 1943 and the land returned to former owners.

St Brides, South Glamorgan

St Brides became operational on 3 April 1941 as No. 6 Satellite Landing Ground for No. 19 MU at St Athan. The site was situated south of the village of St Bride's Major just off the B4265 road. It was regarded as primitive as it only consisted of just basic requirements for an SLG. A few hedges were removed to accommodate two grass landing strips. Initially, personnel were accommodated in tents or transported by road from St Athan or Llandow. In order to provide some degree of comfort a Nashcrete canteen building was built in October 1943 but it was not until May 1944 that a Robin hangar together with a small concrete apron was built for minor

maintenance. The first aircraft to be stored at St Brides were seventeen Hurricanes followed by twelve Beaufighters and a few Beauforts and Henleys. Records show that there were fifty-five various aircraft stored at the site in May 1943. Over the following years this number gradually declined. By 1945 the importance of St Brides as a SLG diminished and was ear-marked for closure. Although it was de-requisitioned in July, an area around the hangar was used by the Bristol Aircraft Company for breaking-up Henleys and Beaufighters. It was finally closed on 26 September 1945 and the area was reverted back to farming.

Acknowledgements

The author would like to thank the numerous people who have contributed a wealth of information and photographs. Without their assistance this book would not have been possible. Special thanks are extended to the following: Deric Brock, Simon Broomfield, John Evans, Trevor Francis, Ben Owen, Capt. W Thomas (Pembrey Airport) Valley Aviation Group.

My thanks also extends to various organisations such as Aberporth West Wales Airport, Airbus UK, Airfield Research Group, Air Heritage (Wales), Caernarfon Airport, Cardiff International Airport, DARA, staff at Photograph Archive of the Welsh Assembly Government, RCAHMW, RAF Museum.

Books consulted include:

Brawdy Stronghold in the West, History Press, 2009
Civil Aviation in Wales, Bridge Books, 2008
Defending Wales The Coast and Sea Lanes in Wartime, Amberley Publishing, 2010
Military Airfields of Wales, Bridge Books, 2004